Coloring the Universe

Draw, Color and Explore with Lebo

David Lebatard

mango
PUBLISHING

CORAL GABLES

Cover Design: David Lebatard
Cover Photo/illustration: David Lebatard
Interor illustrations: David Lebatard
Layout & Design: Elina Diaz & Nick Sarno

For permission requests, please contact the publisher at:
Mango Publishing Group
2850 S Douglas Road, 2nd Floor
Coral Gables, FL 33134 USA
info@mango.bz

For special orders, quantity sales, course adoptions and corporate sales, please email the publisher at sales@mango.bz. For trade and wholesale sales, please contact Ingram Publisher Services at customer.service@ingramcontent.com or +1.800.509.4887.

Coloring the Universe: Draw, Color and Explore with Lebo

ISBN: (print) 978-1-64250-541-2 , (ebook) 978-1-64250-542-9
BISAC category code: ART058000, ART / Graffiti & Street Art

Printed in the United States of America

Dedicated to the wonderers and the wanderers, the ancient explorers and the inner alchemists, the architects of ideas and the detectives of mystery, magic and miracles. May you always follow, be and free the light.

Introduction

Pictures—cartoons in particular—have always fascinated me. As a child daily comic strips and Saturday morning cartoons were more real to me than my surroundings, yet they had an eerie mystical quality (one that still stirs me today). I later became a student of ancient history and through that I discovered ancient hieroglyphs, cuneiform, and really all written languages have their roots firmly planted in visually iconography—or in simple terms, cartooning. When we go back further still, we see ancient cave drawings dating back tens of thousands of years before the first block was set for the pyramids at Giza. In short, cartooning and drawing are part of what Carl Jung defined as our collective unconscious, and symbols form a visual language that is in the deepest parts of our DNA. I hope that through this book you find the same joy and fascination I've been blessed to find in imagery and that you take it even further. I hope you tap into your inner child when you color some of these pages, and I hope you find your inner shaman when you learn to draw the stuff that brought us this far—the things that root us to the earth and extend our heads into the heavens. I hope you have fun, and learn, and wonder, and wander. Above all, I hope you learn that we are one.

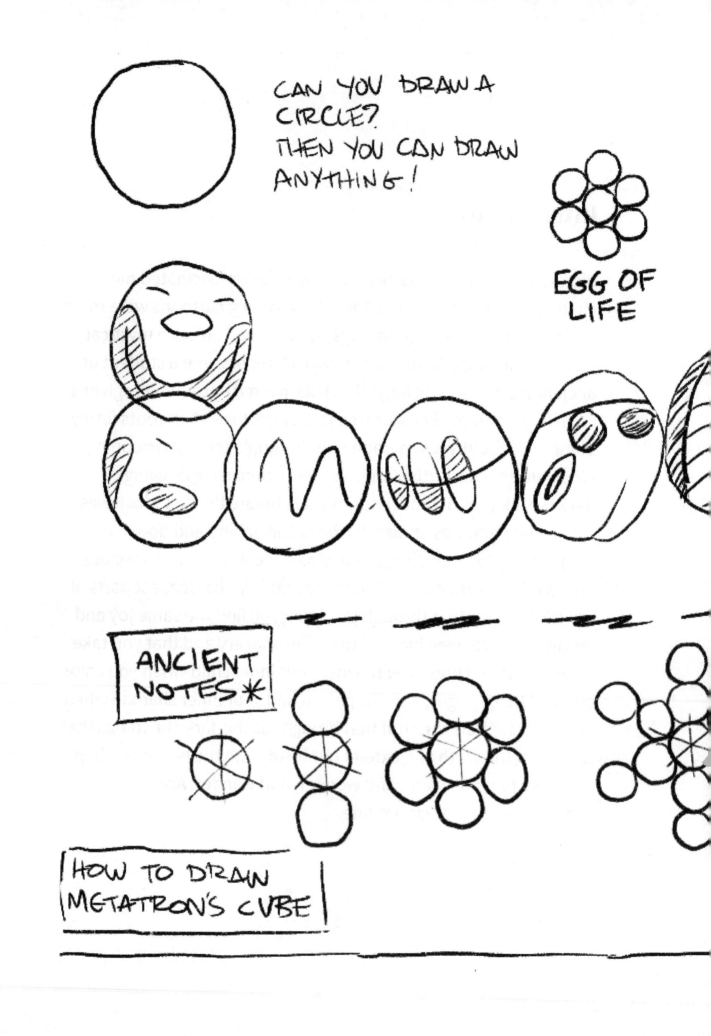

CAN YOU DRAW A CIRCLE?
THEN YOU CAN DRAW ANYTHING!

EGG OF LIFE

ANCIENT NOTES *

HOW TO DRAW METATRON'S CUBE

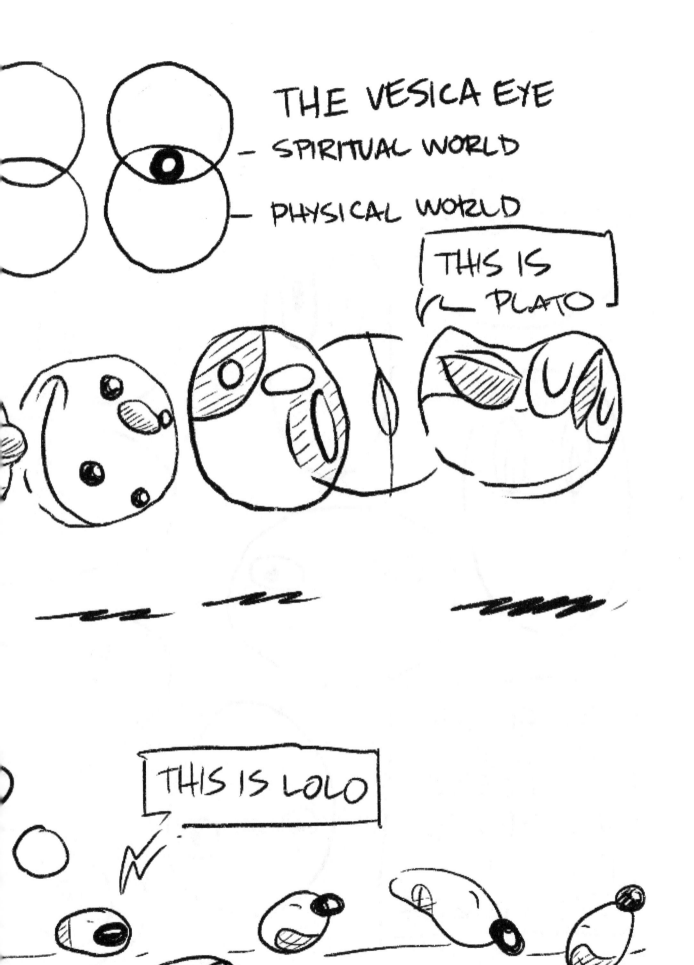

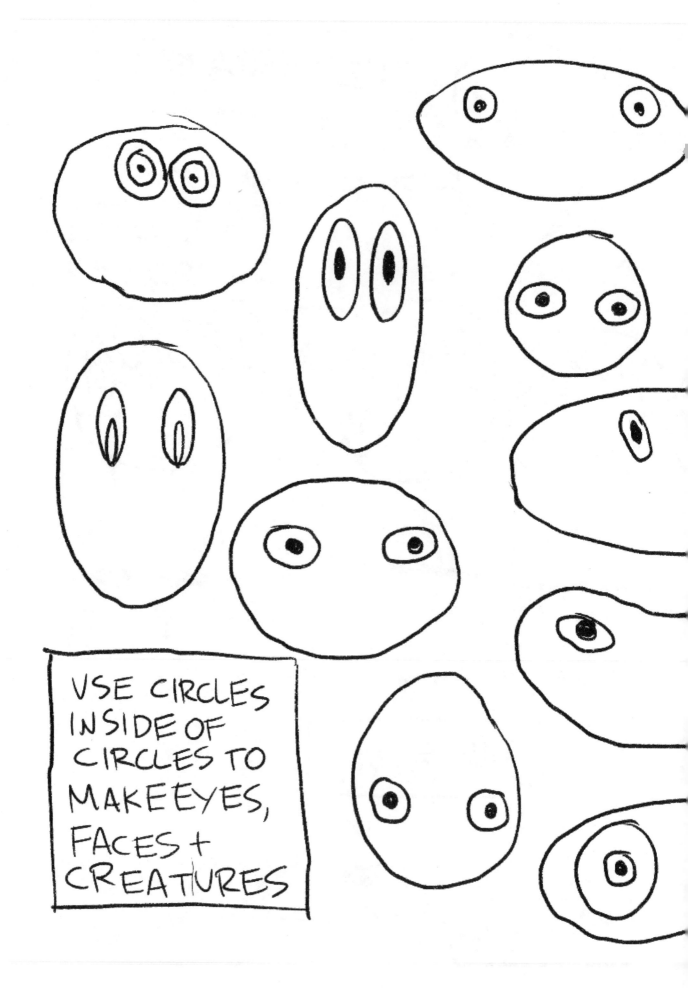

USE CIRCLES INSIDE OF CIRCLES TO MAKE EYES, FACES + CREATURES

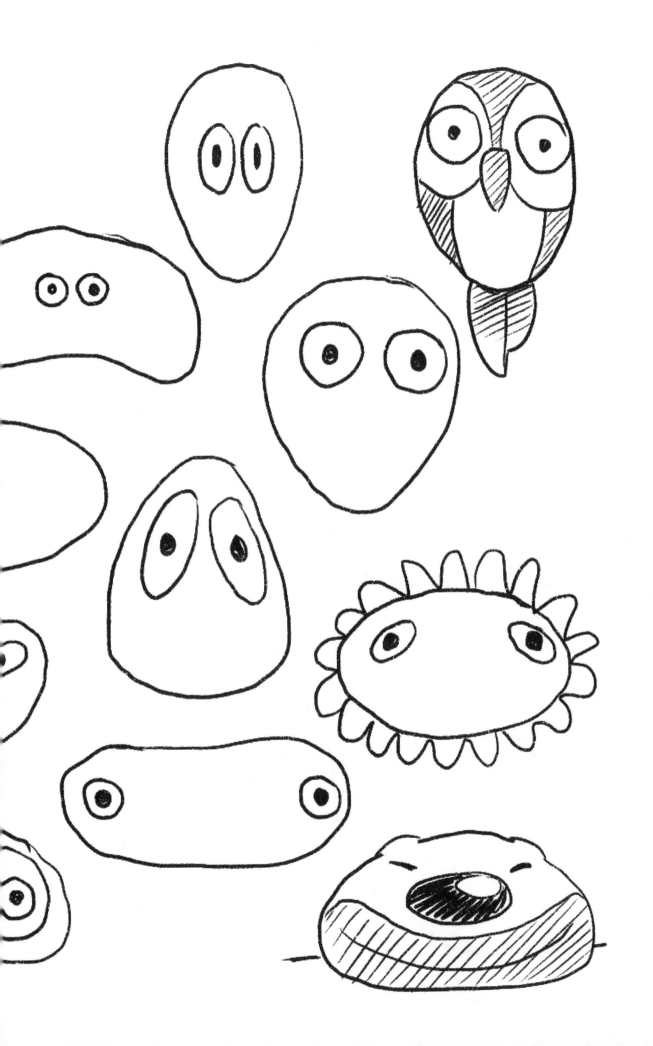

NOW TAKE YOUR CIRCLE FOR

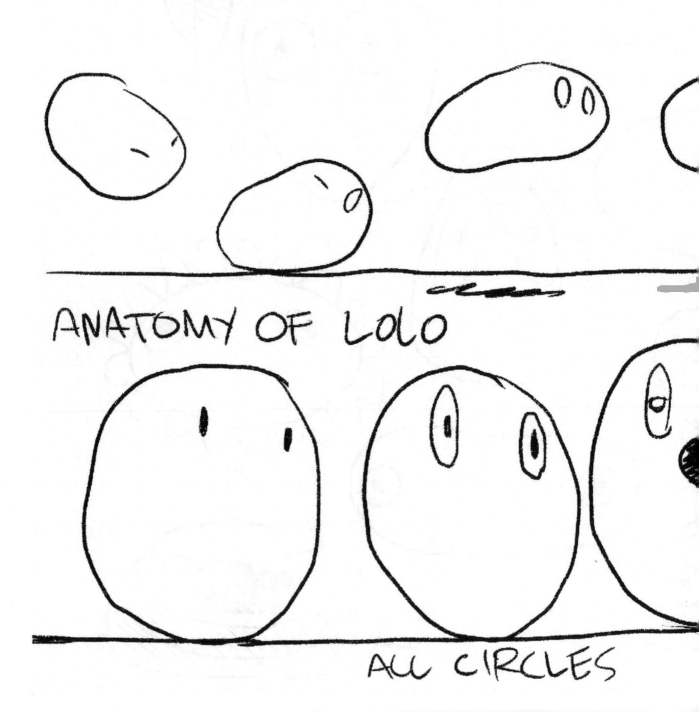

ANATOMY OF LOLO

ALL CIRCLES

ALK...

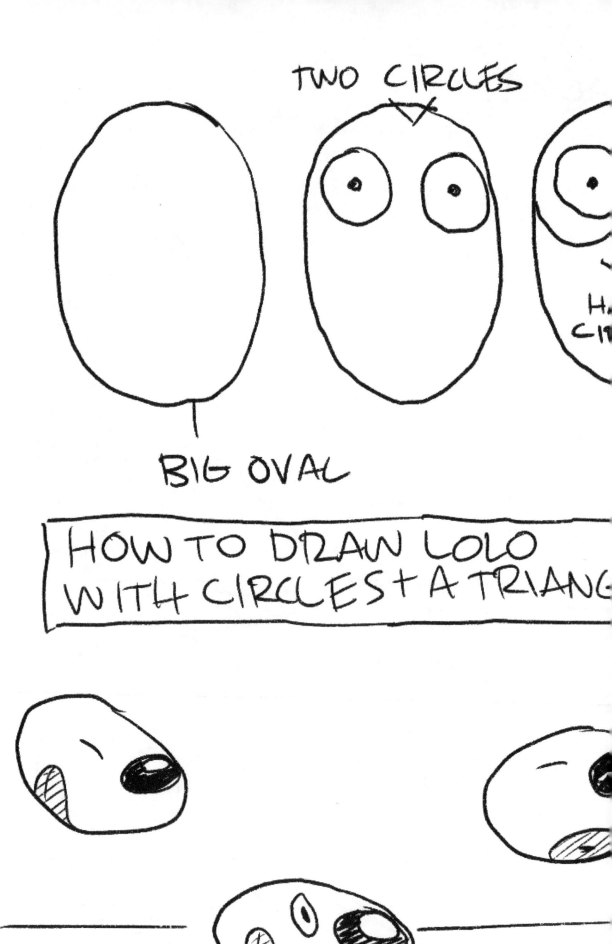

TWO CIRCLES

BIG OVAL

HOW TO DRAW LOLO
WITH CIRCLES + A TRIANG

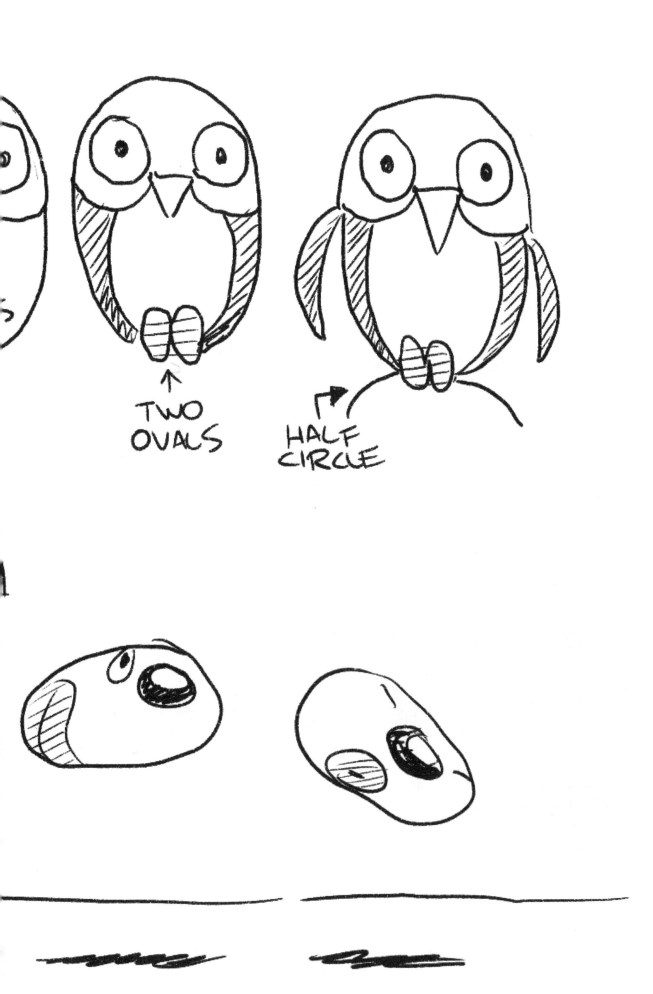

TWO
OVALS

HALF
CIRCLE

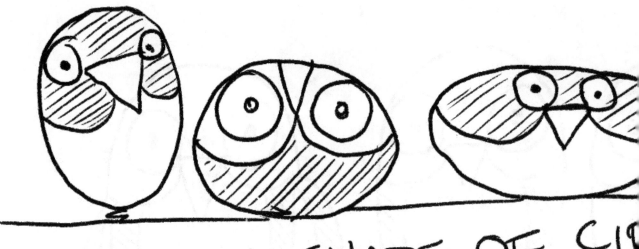

PLAY WITH SHAPE OF CI[R]
TO GET DIFFERENT CH[...]

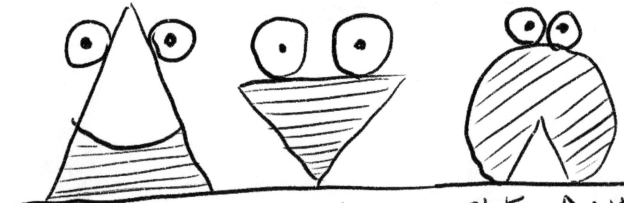

NOW PLAY WITH CIRCLE AND
TO CREATE DIFFERENT CH[...]

LOLO LEARNS
TO FLY

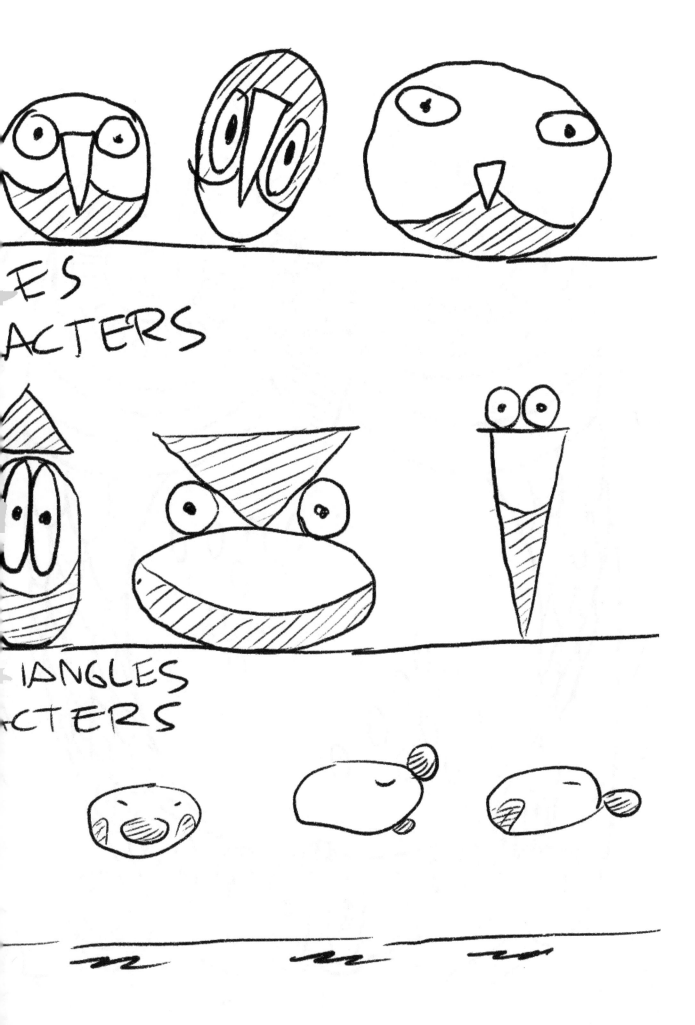

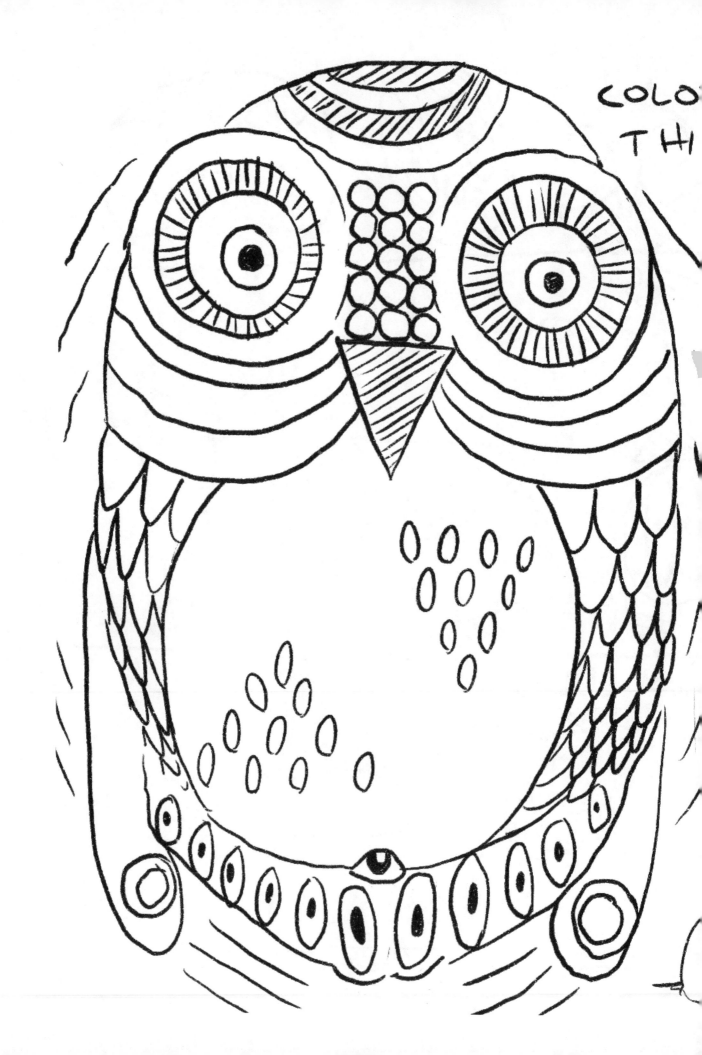

COLO
THI

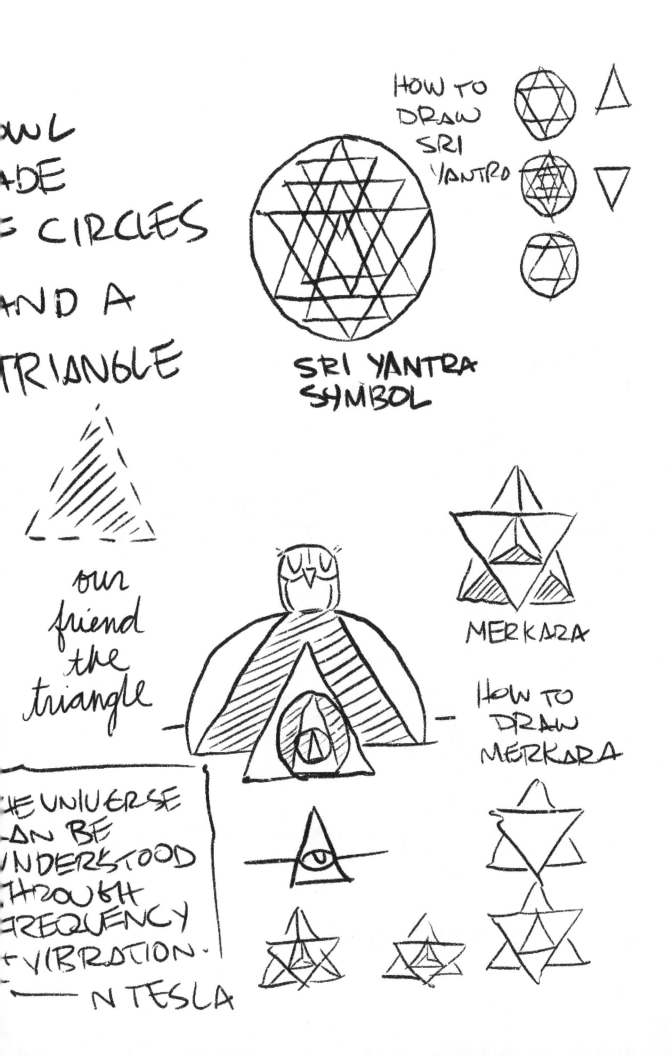

HOW TO
DRAW
SRI
YANTRA

SRI YANTRA
SYMBOL

WL
DE
CIRCLES

ND A

TRIANGLE

our
friend
the
triangle

MERKARA

HOW TO
DRAW
MERKARA

HE UNIVERSE
AN BE
NDERSTOOD
THROUGH
FREQUENCY
+ VIBRATION.
— N TESLA

HOW TO DRAW THE UNIVERSE WITH LEBO

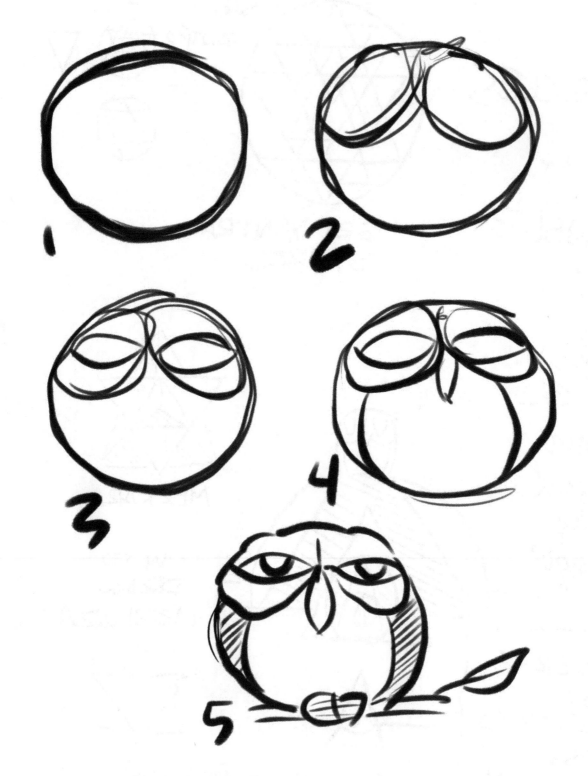

HOW TO DRAW A LEBO OWL

DRAW YOUR OWN...

HOW TO DRAW THE UNIVERSE WITH [LEBO]

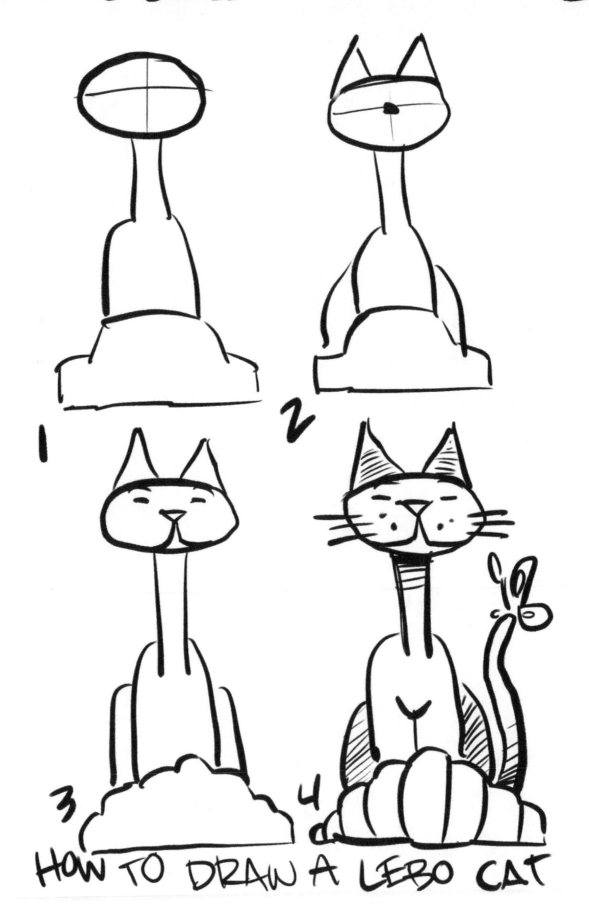

1

2

3

4

HOW TO DRAW A LEBO CAT

DRAW YOUR OWN...

HOW TO DRAW THE UNIVERSE WITH LEBO

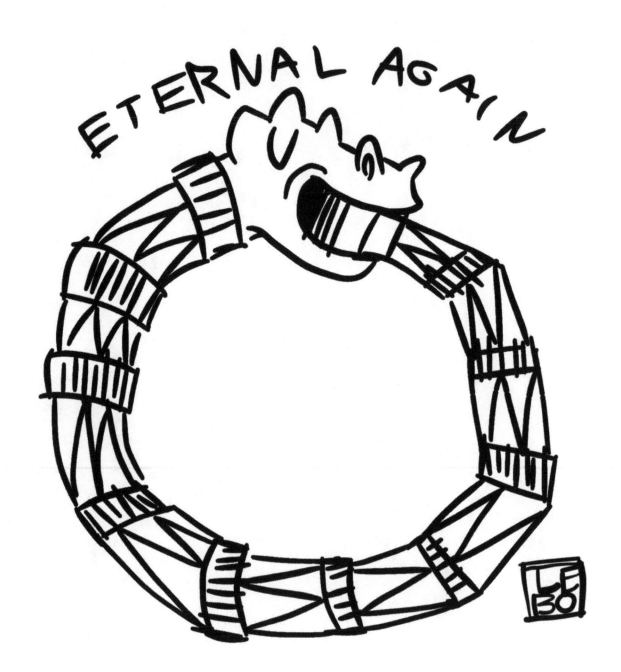

ETERNAL AGAIN

COLOR ME...

DRAW YOUR OWN...

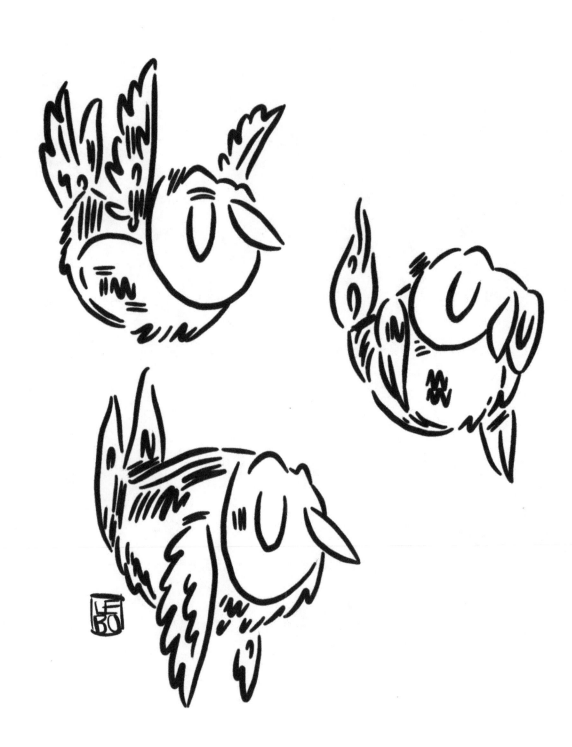

COLOR ME...

DRAW YOUR OWN...

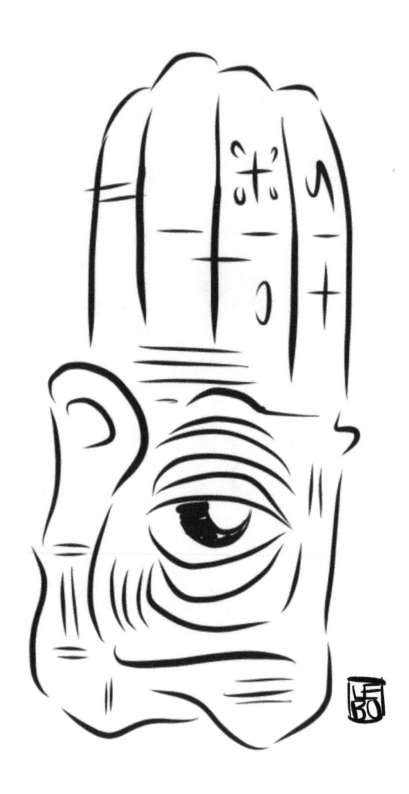

COLOR ME...

DRAW YOUR OWN...

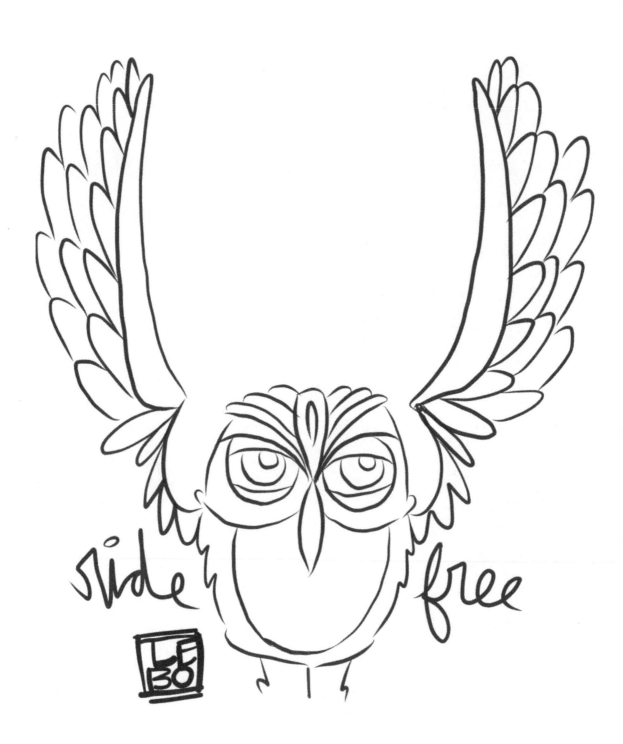

COLOR ME...

DRAW YOUR OWN...

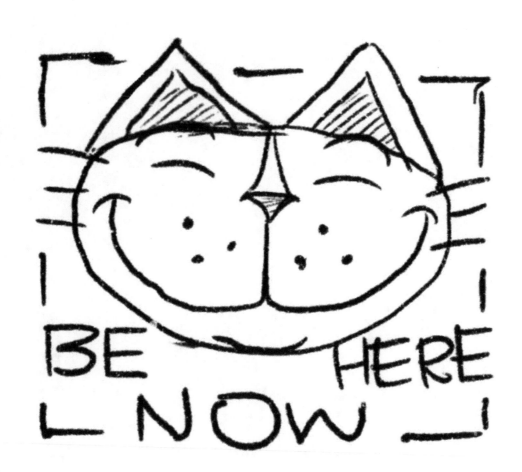

BE HERE NOW

COLOR ME...

DRAW YOUR OWN...

HOW TO DRAW THE UNIVERSE WITH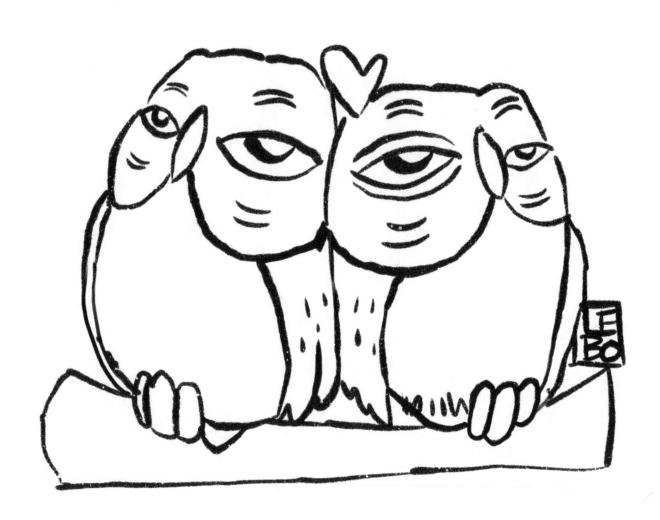

COLOR ME...

DRAW YOUR OWN...

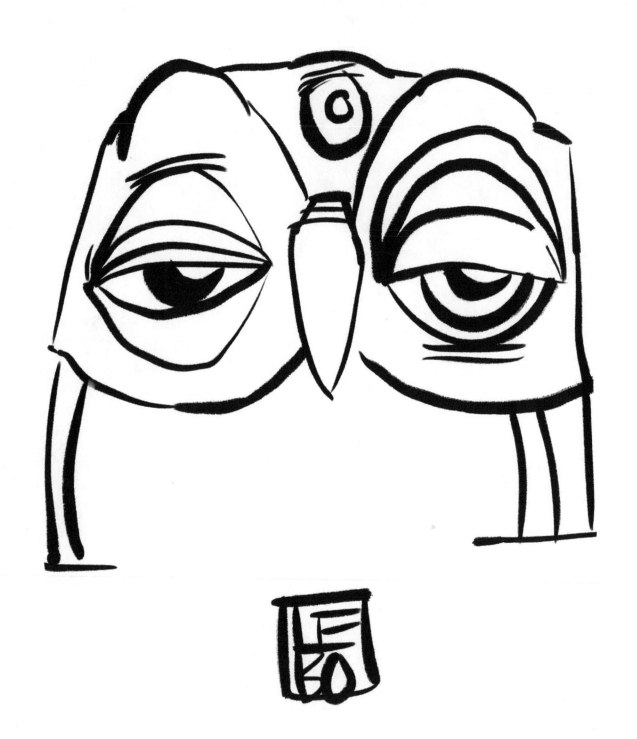

COLOR ME...

DRAW YOUR OWN...

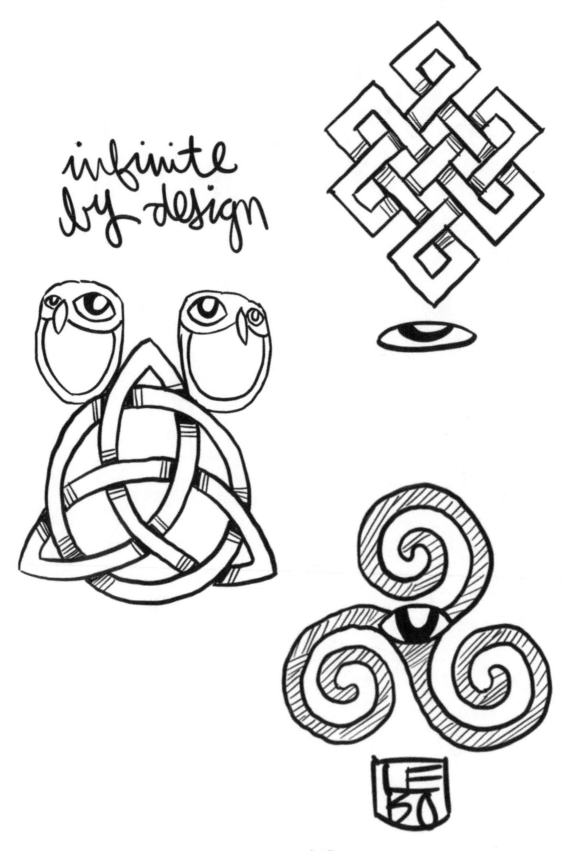

infinite by design

COLOR ME...

DRAW YOUR OWN...

HOW TO DRAW THE UNIVERSE WITH

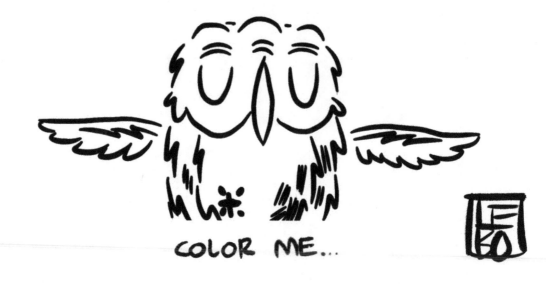

COLOR ME...

DRAW YOUR OWN...

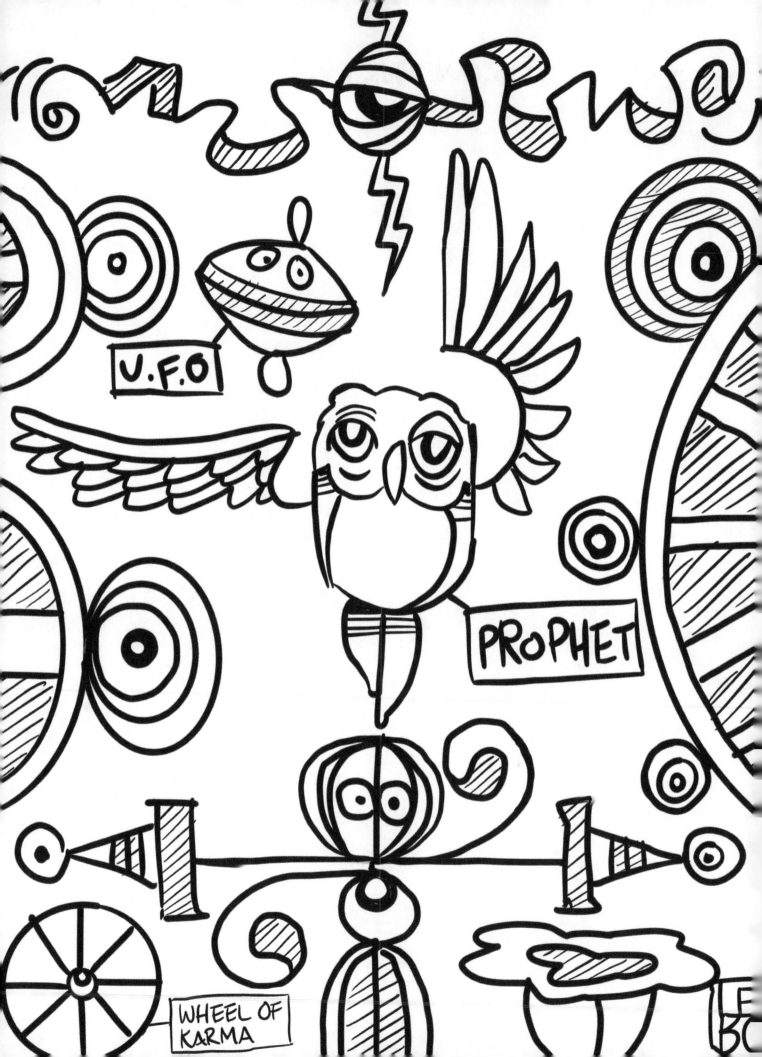

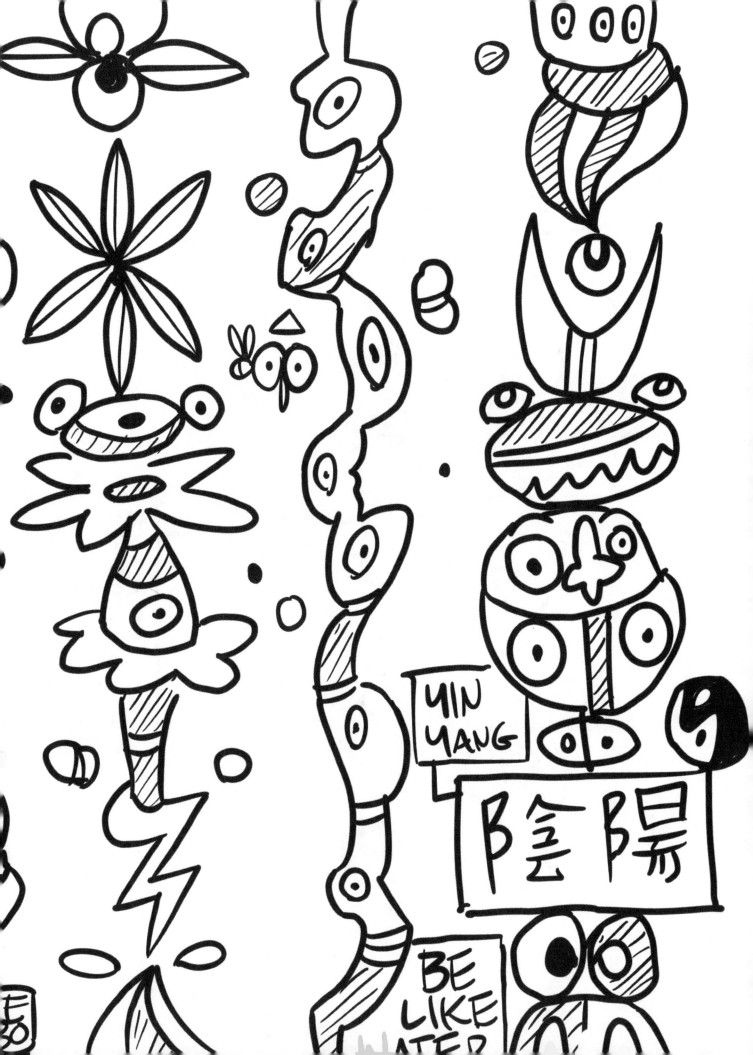

YIN
YANG

陰陽

BE
LIKE
WATER

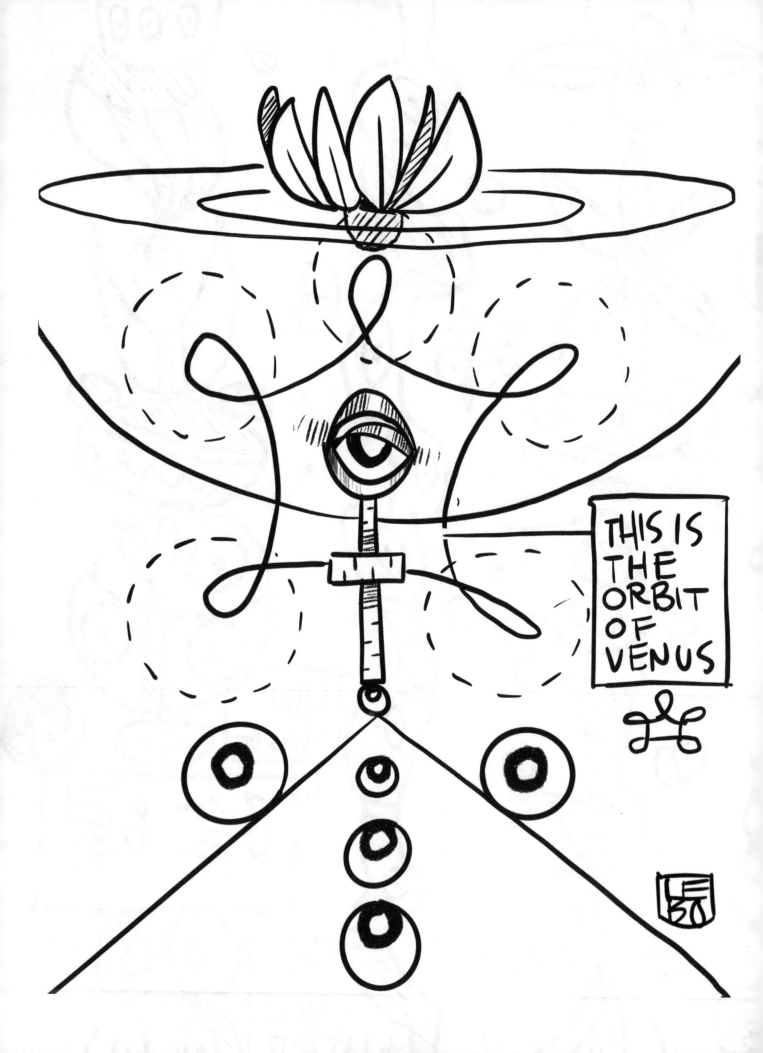

THIS IS
THE
ORBIT
OF
VENUS

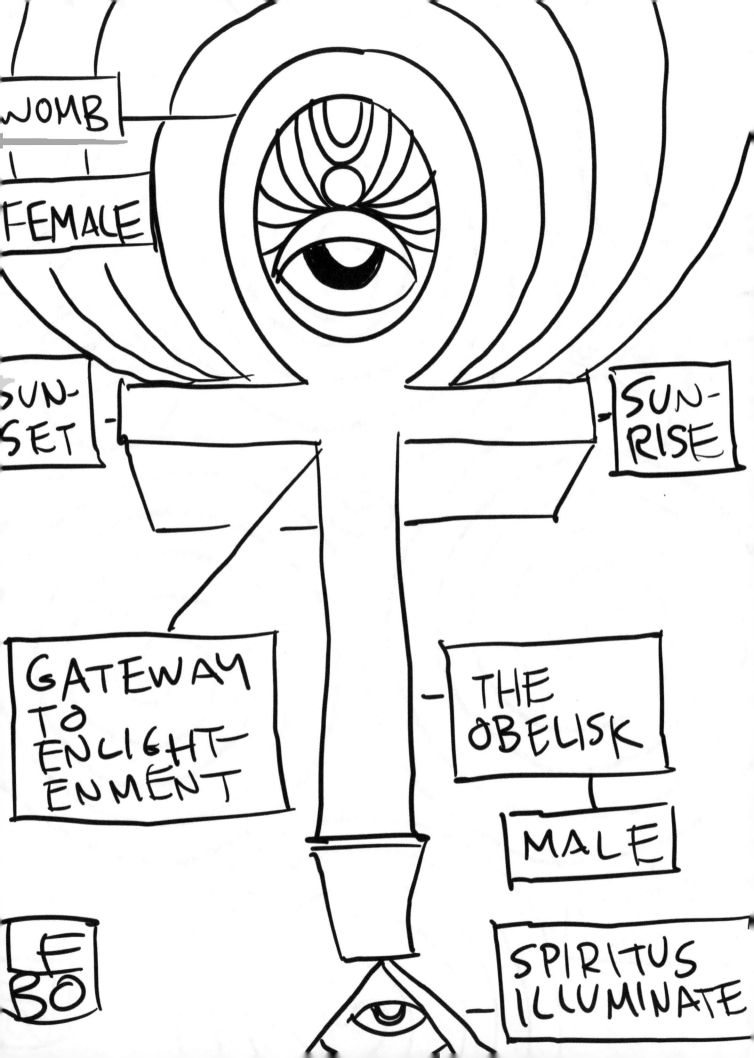

WOMB

FEMALE

SUN-SET

SUN-RISE

GATEWAY TO ENLIGHT-ENMENT

THE OBELISK

MALE

EBO

SPIRITUS ILLUMINATE

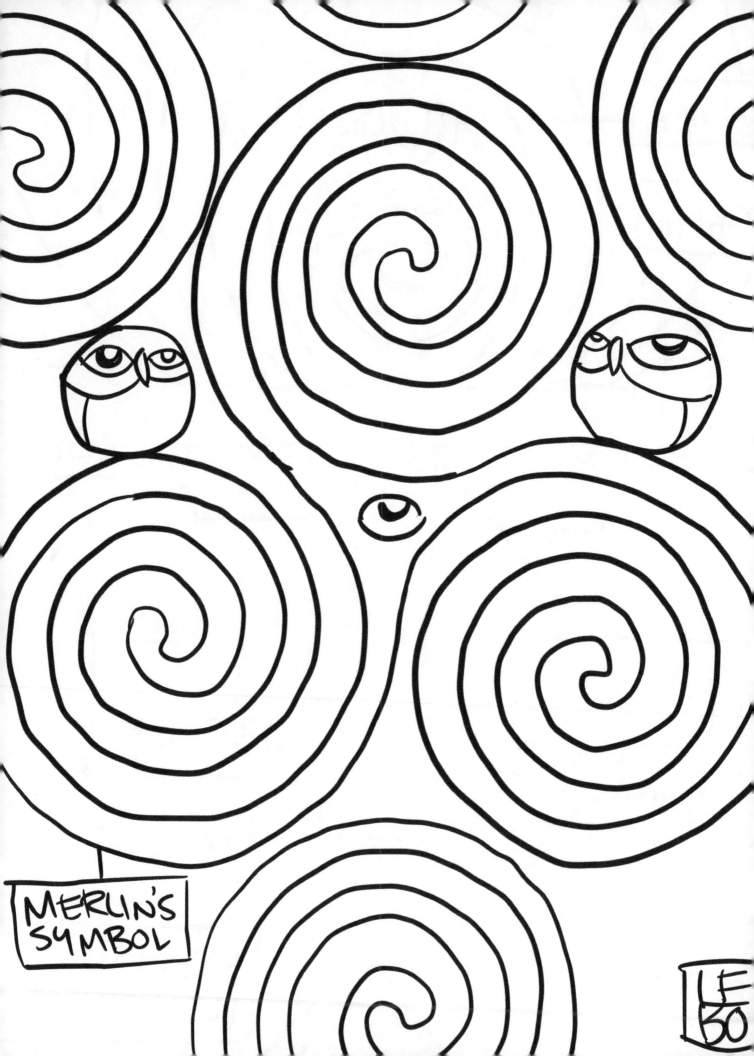

MERLIN'S SYMBOL

LE
50

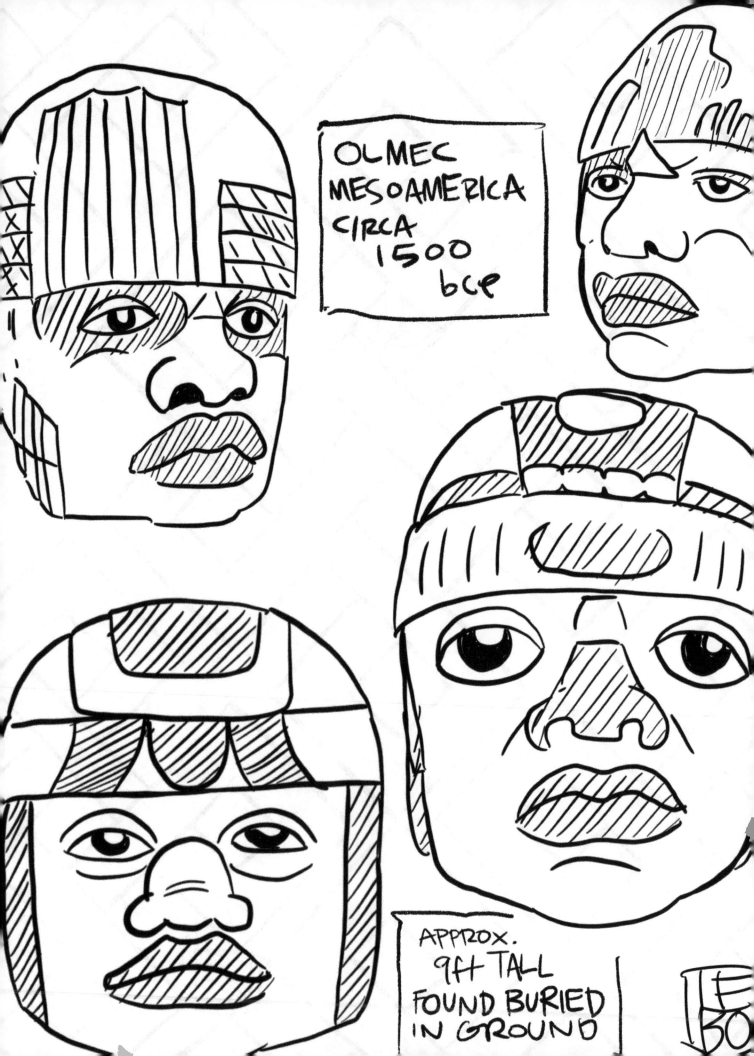

OLMEC
MESOAMERICA
CIRCA
1500
bce

APPROX.
9ft TALL
FOUND BURIED
IN GROUND

FAMOUS MASKS THROUGHOUT HISTORY

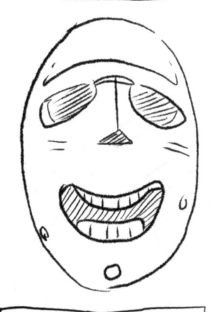

OLDEST KNOWN MASK - 4,000 BCE JERUSALEM

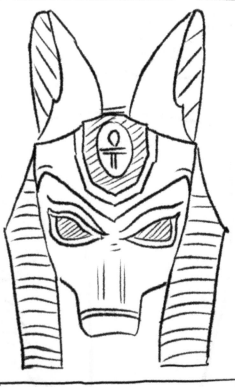

3,000 BCE - EGYPT

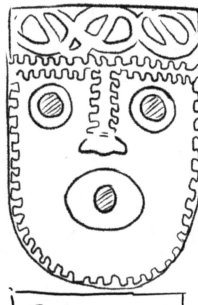

2,000 BCE IRELAND CELTIC

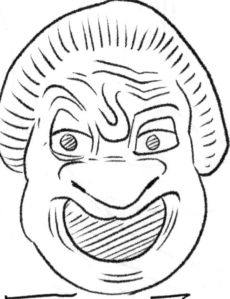

800 BCE GREECE

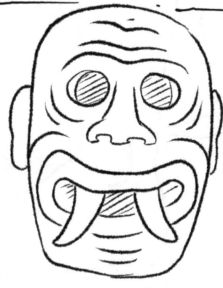

1,400 CE PERU

EARTH 2020 CE

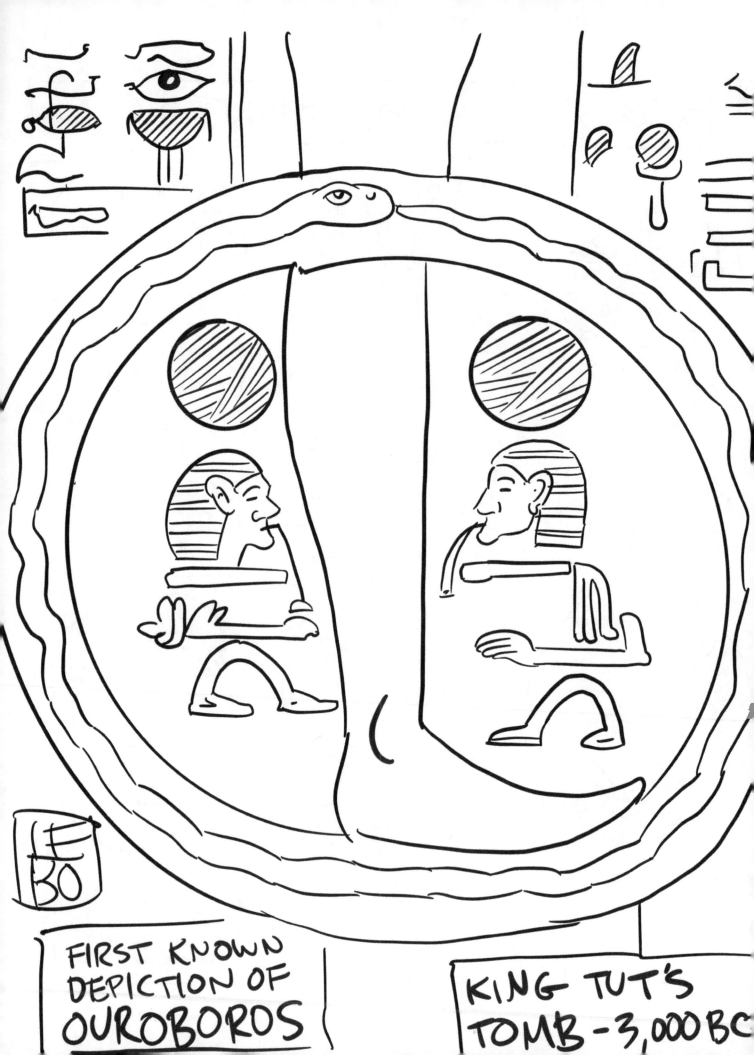

FIRST KNOWN
DEPICTION OF
OUROBOROS

KING TUT'S
TOMB - 3,000 BC

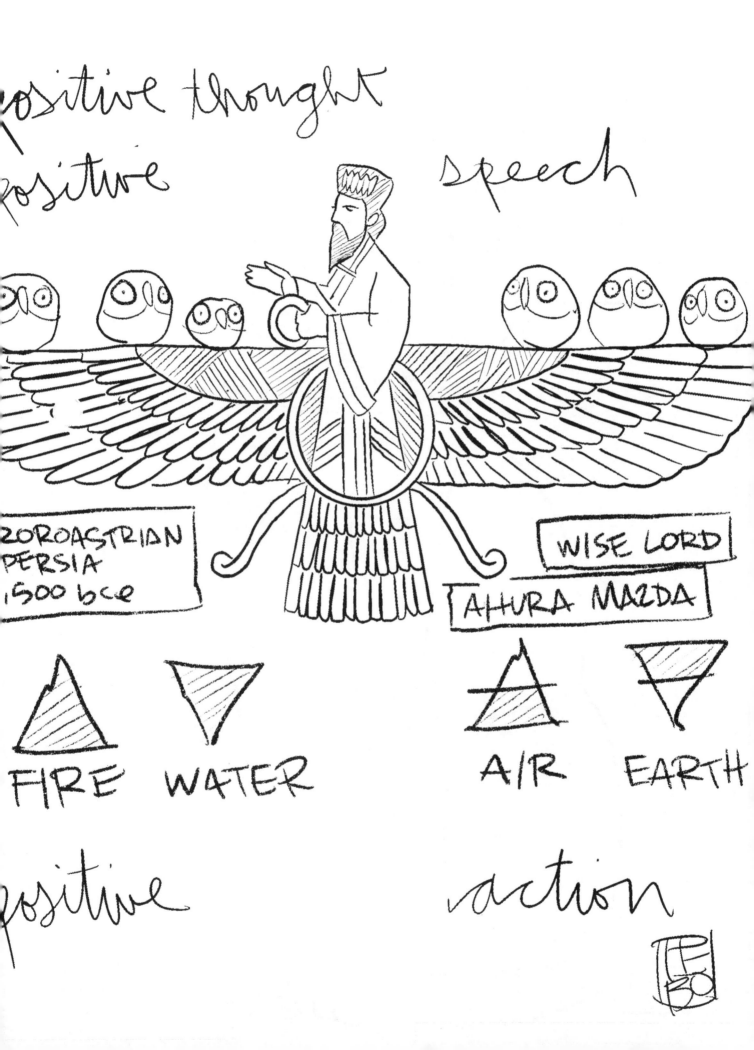

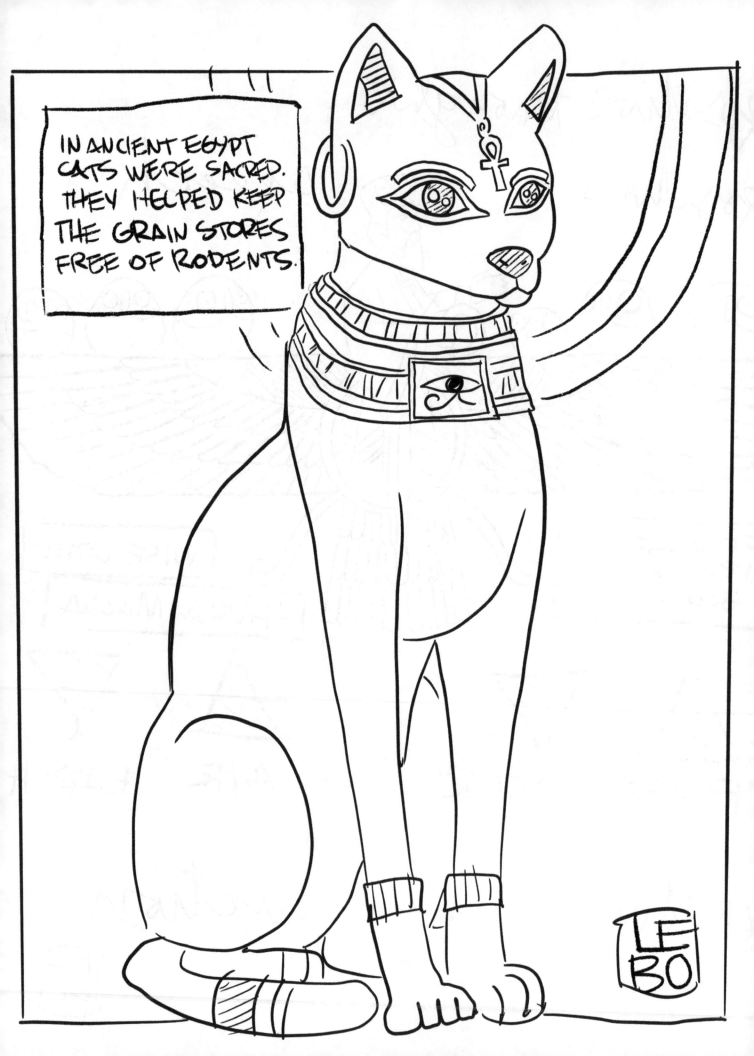

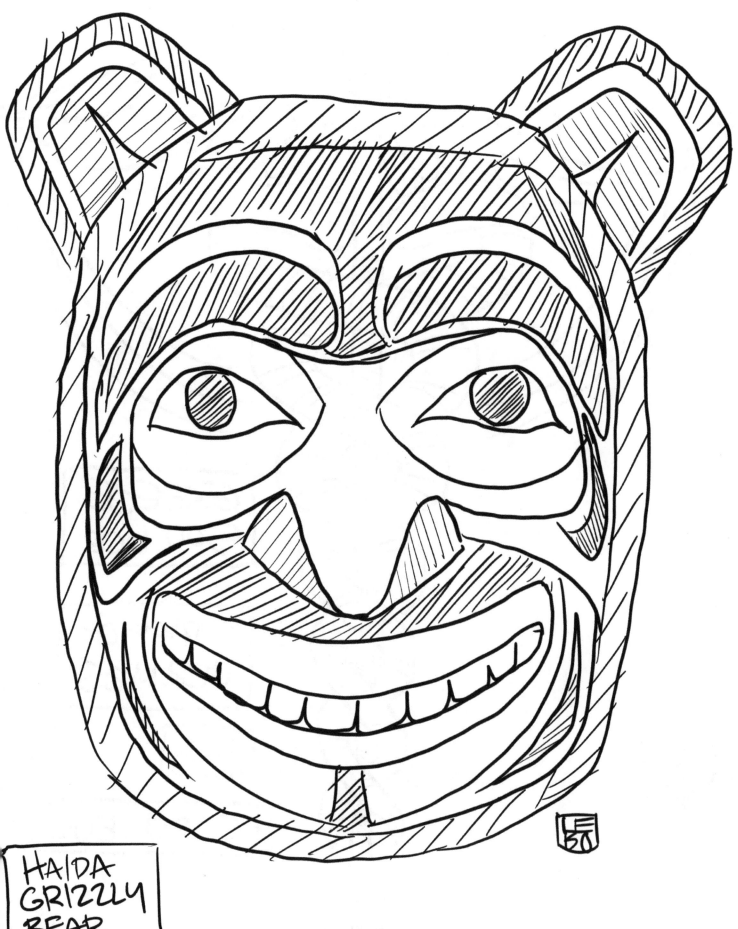

HAIDA
GRIZZLY
BEAR
MASK

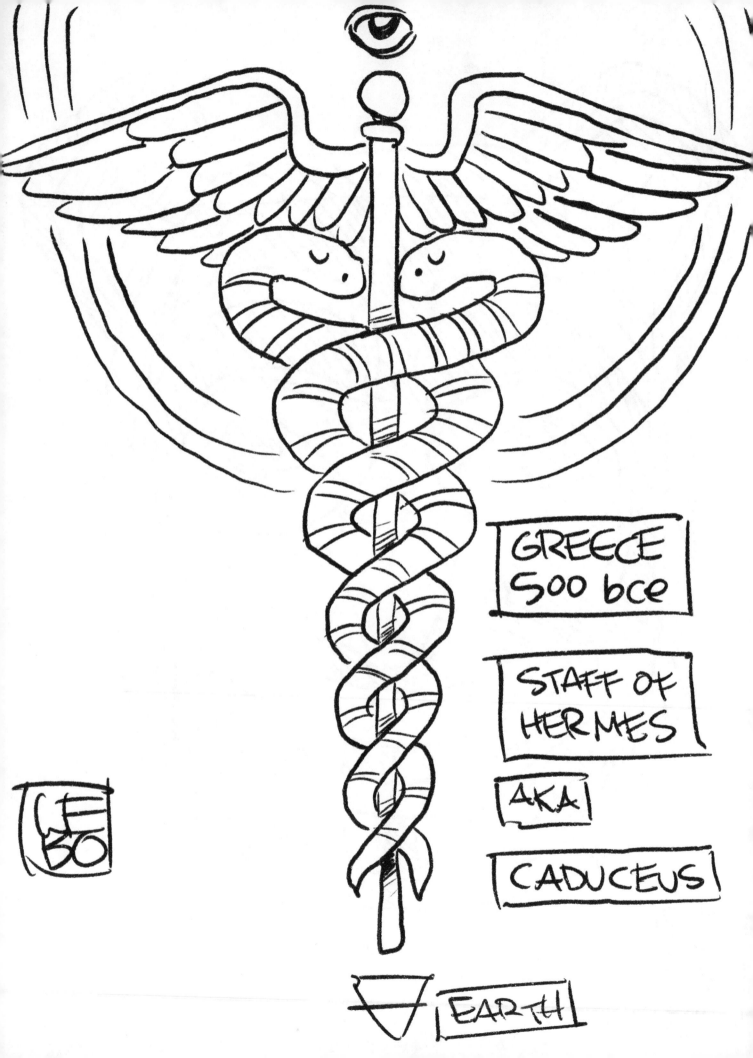

GREECE
500 bce

STAFF OF
HERMES

A.K.A

CADUCEUS

▽ EARTH

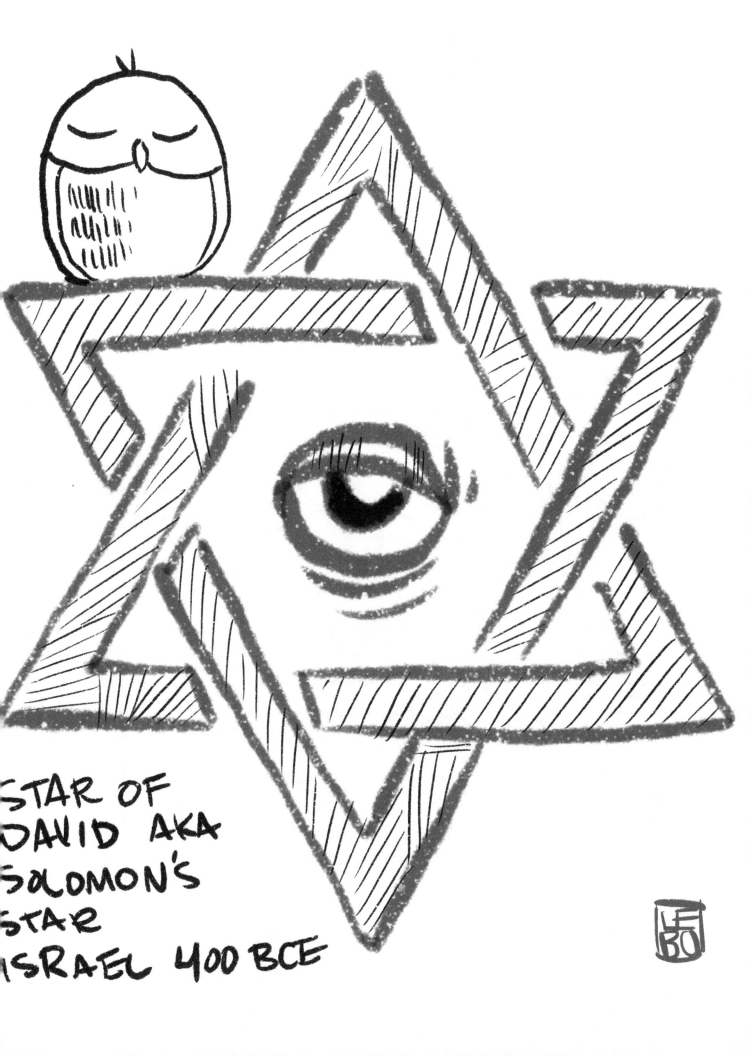

STAR OF
DAVID AKA
SOLOMON'S
STAR
ISRAEL 400 BCE

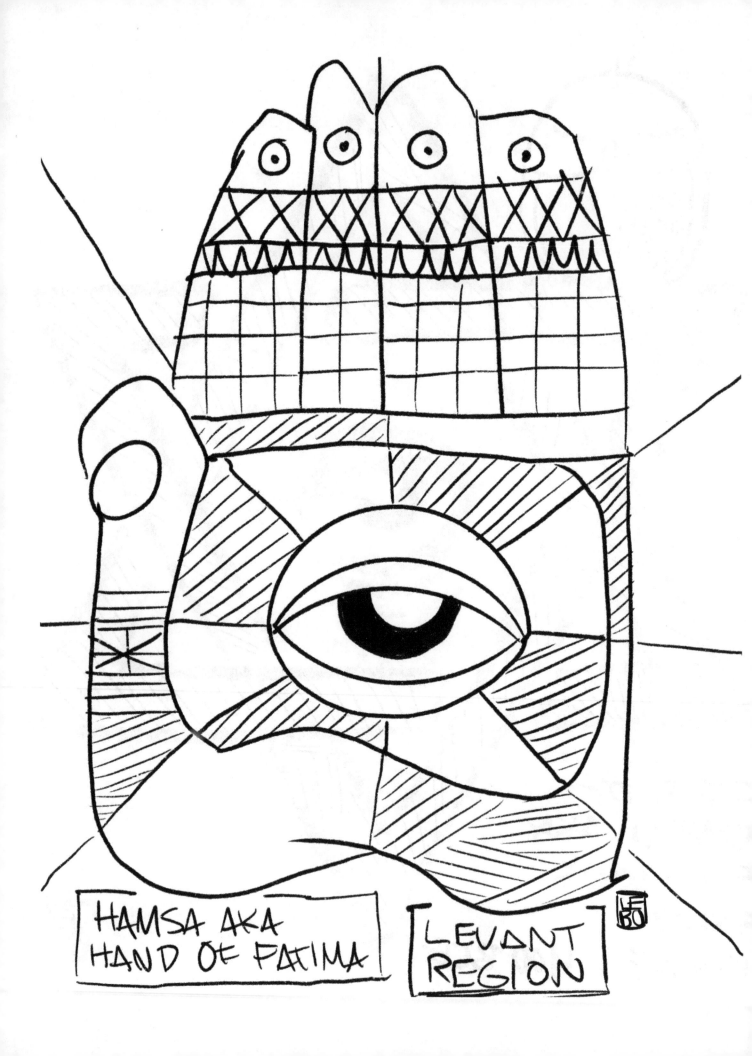

HAMSA AKA
HAND OF FATIMA

LEVANT
REGION

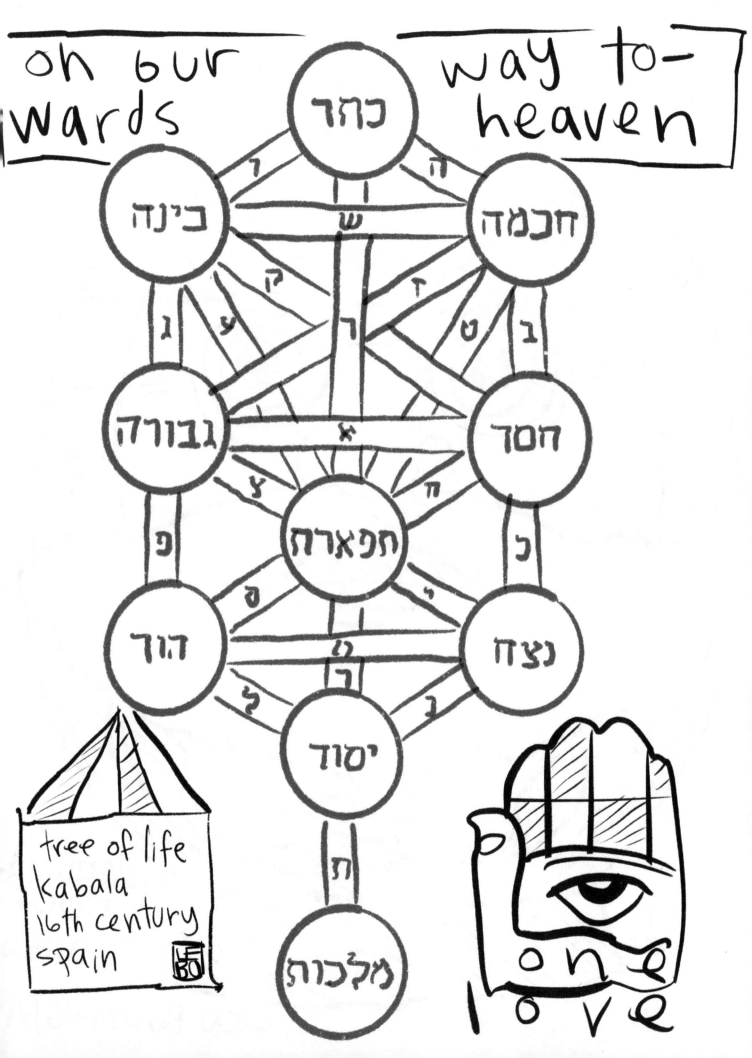

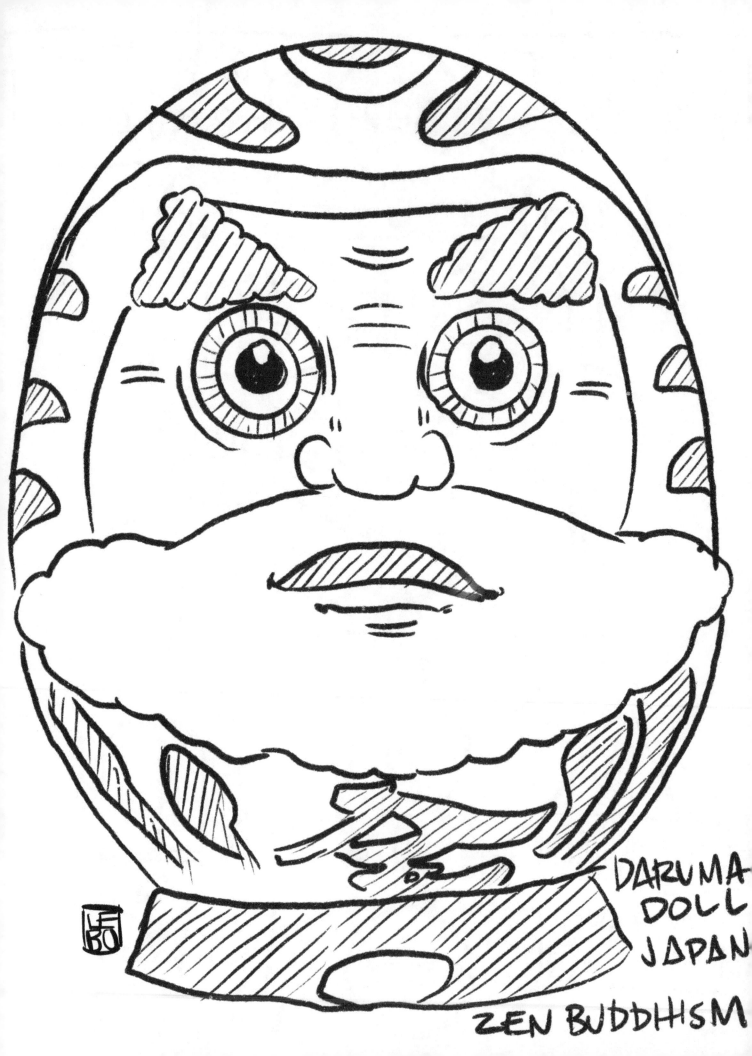

DARUMA
DOLL
JAPAN

ZEN BUDDHISM

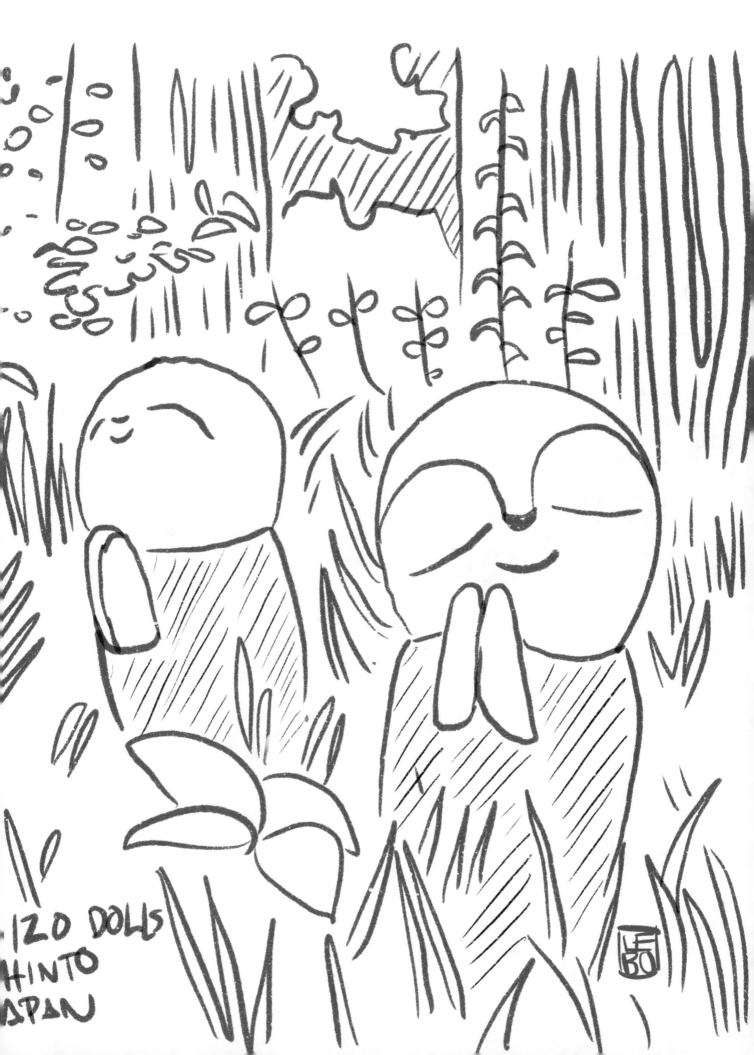

IZO DOLLS
HINTO
JAPAN

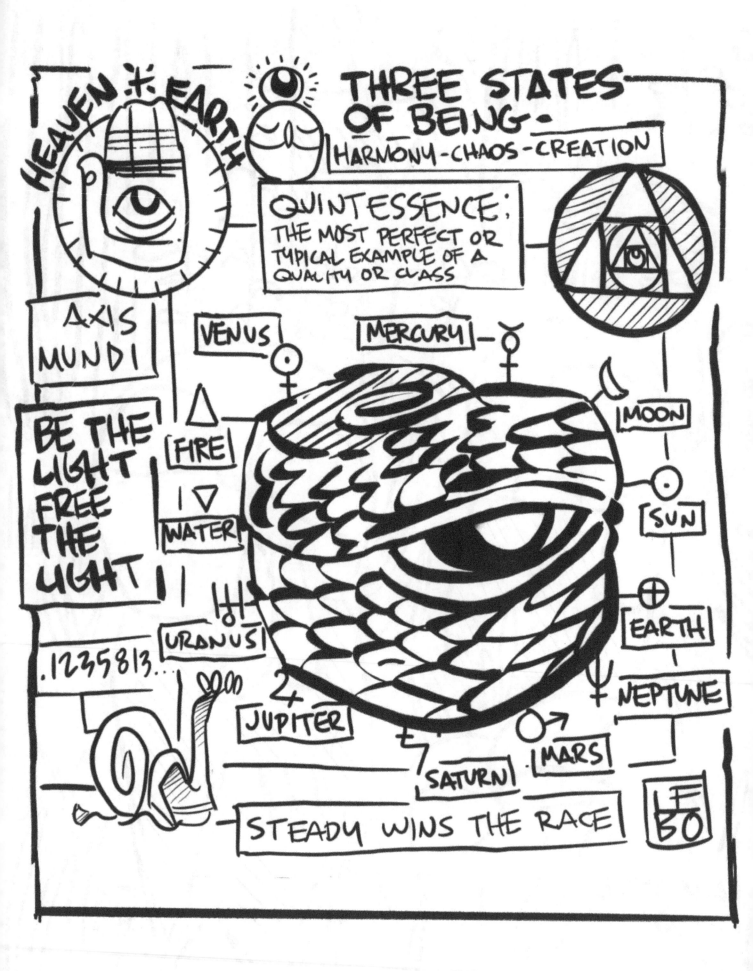

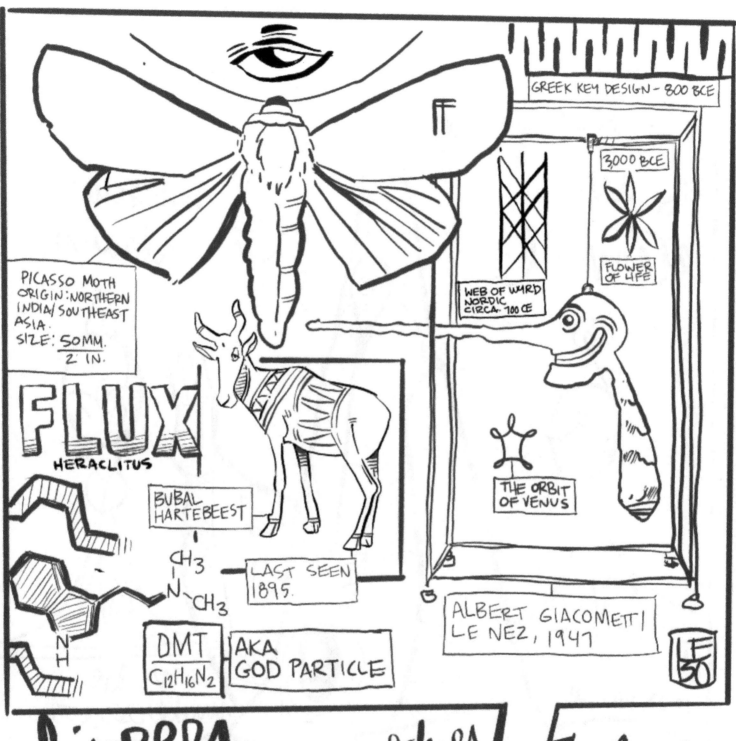

GREEK KEY DESIGN - 800 BCE

IF

3,000 BCE

FLOWER OF LIFE

WEB OF WYRD
NORDIC
CIRCA. 700 CE

PICASSO MOTH
ORIGIN: NORTHERN
INDIA/SOUTHEAST
ASIA.
SIZE: 50MM.
2 IN.

FLUX
HERACLITUS

BUBAL
HARTEBEEST

LAST SEEN
1895.

THE ORBIT
OF VENUS

CH3
N
CH3

DMT
$C_{12}H_{16}N_2$

AKA
GOD PARTICLE

ALBERT GIACOMETTI
LE NEZ, 1947

whispers and echoes echoes echoes echoes echoes

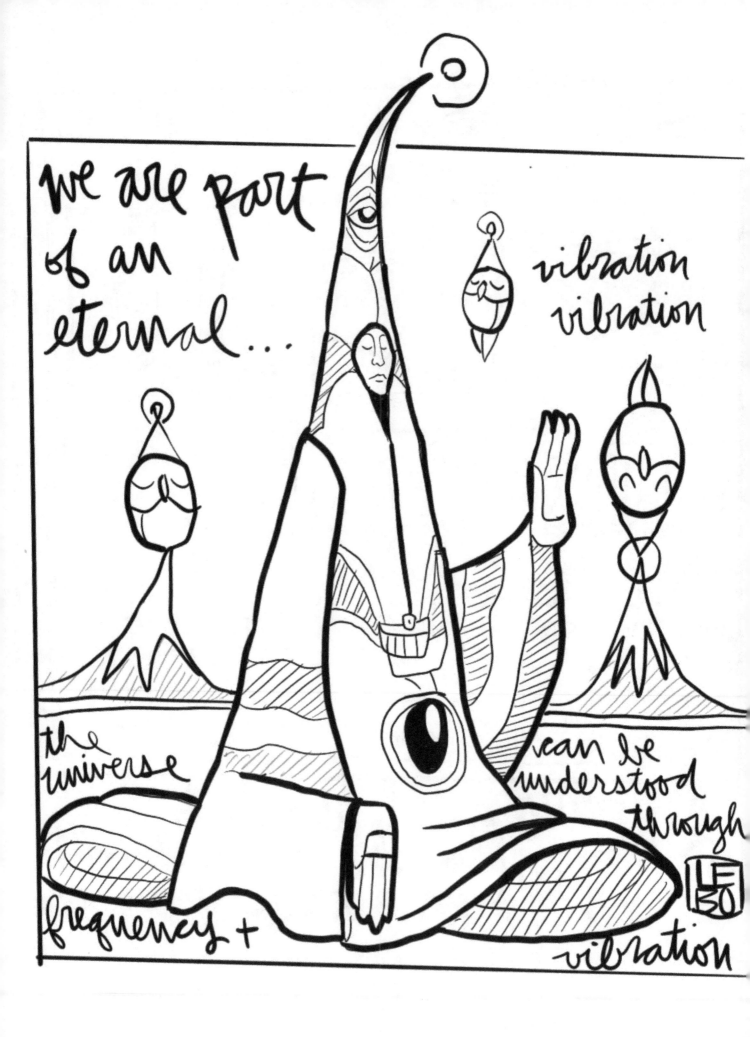

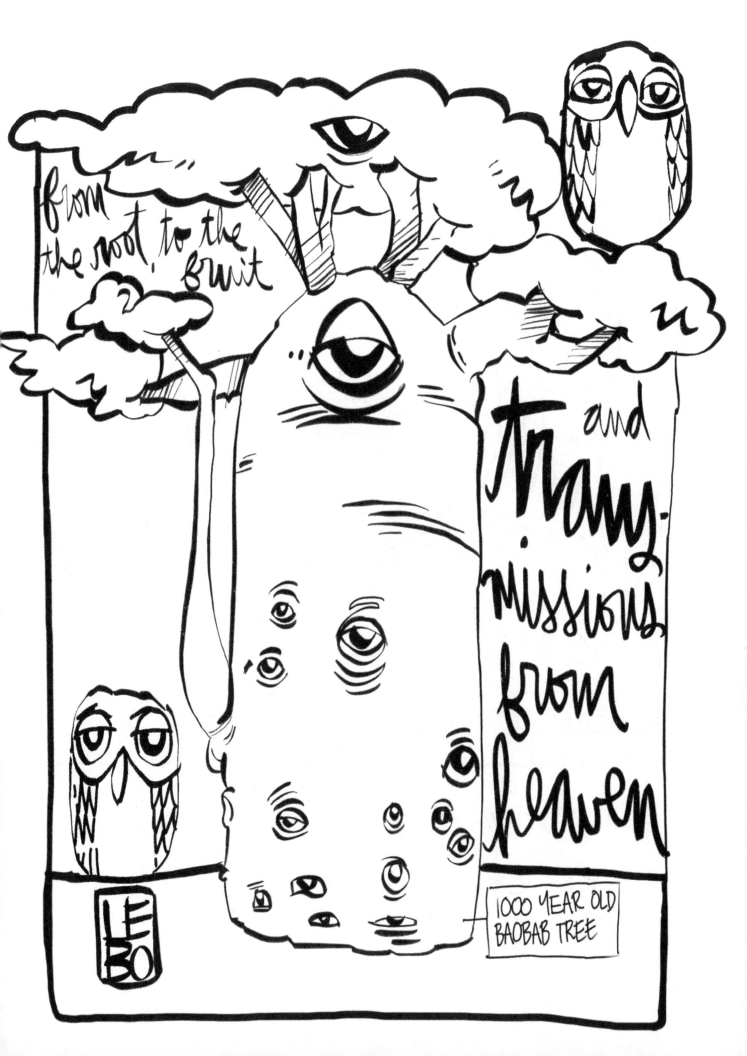

From the root, to the fruit and trans-missions from heaven

LEBO

1000 YEAR OLD BAOBAB TREE

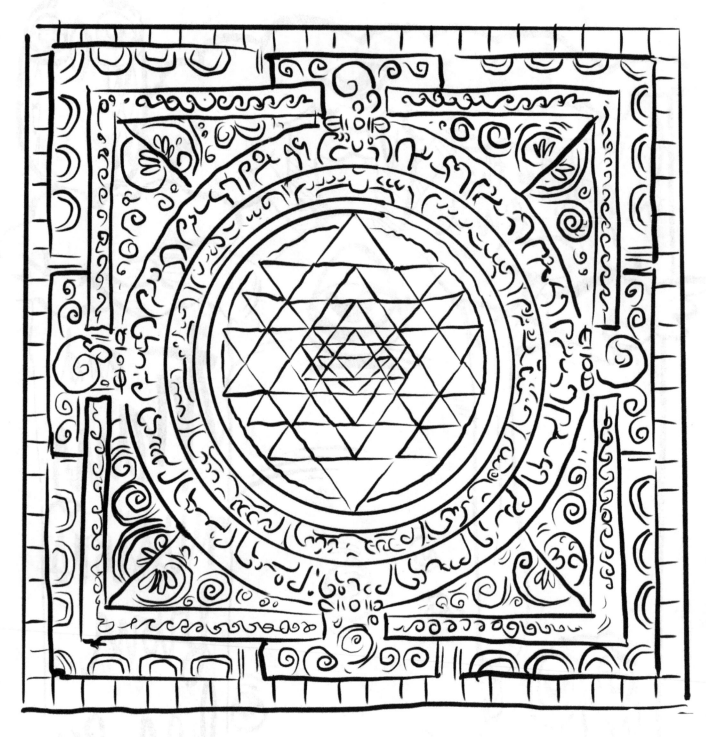

SRI YANTRA mandala - 12,000 years old
concentrating and creating
one's desired outcome
india

ADINKRA- ARE SYMBOLS FROM GHANA THAT REPRESENT CONCEPTS OR APHORISMS. ADINKRA ARE USED EXTENSIVELY IN FABRICS, LOGOS, POTTERY + ON WALLS AND ARCHITECTURAL FEATURES.

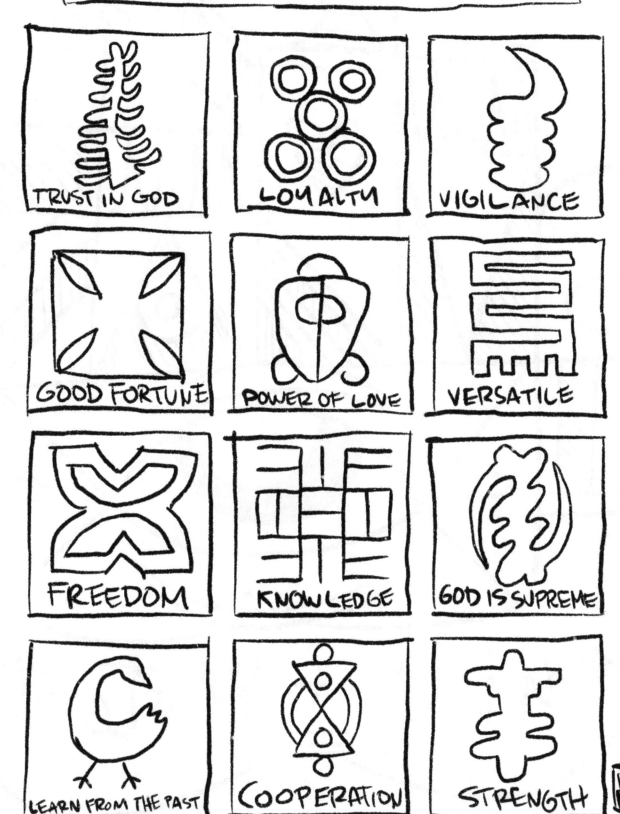

TRUST IN GOD

LOYALTY

VIGILANCE

GOOD FORTUNE

POWER OF LOVE

VERSATILE

FREEDOM

KNOWLEDGE

GOD IS SUPREME

LEARN FROM THE PAST

COOPERATION

STRENGTH

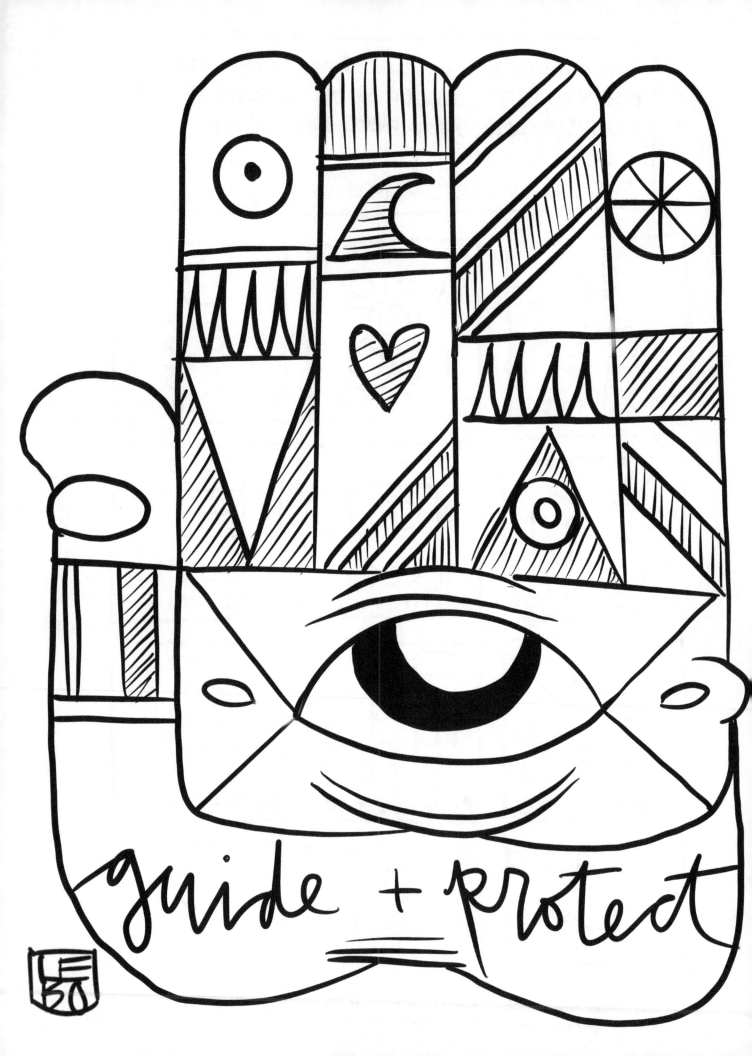

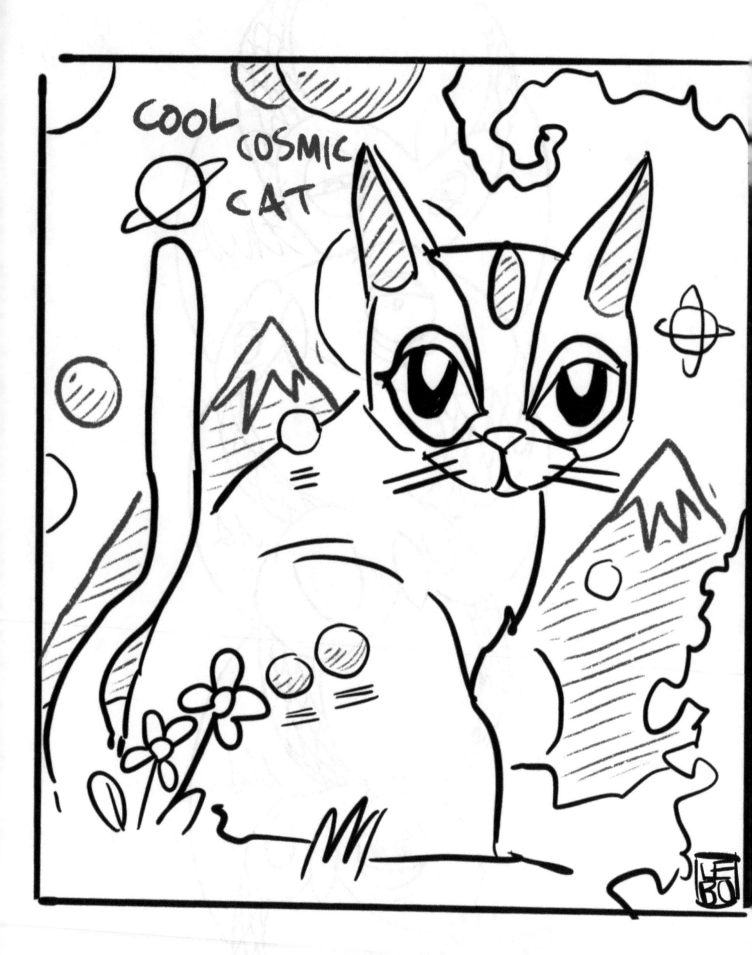

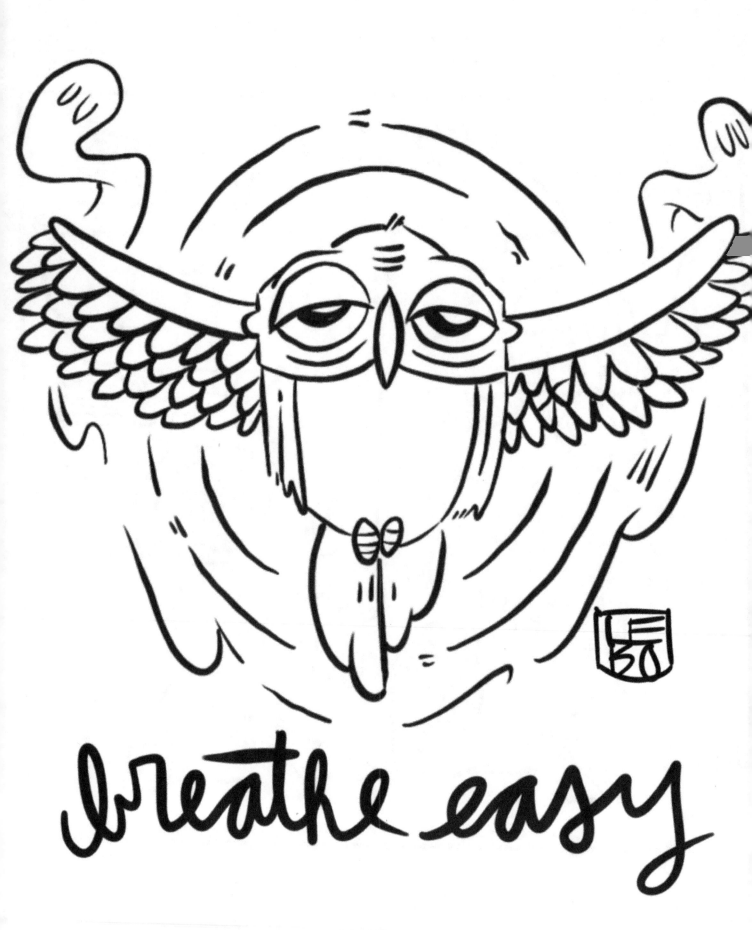

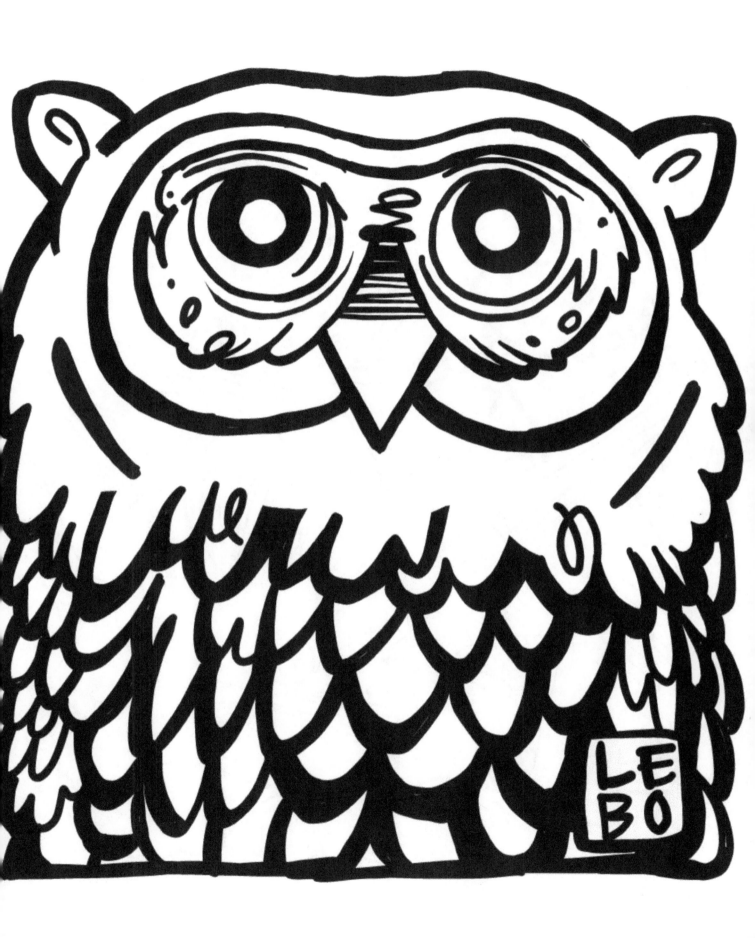

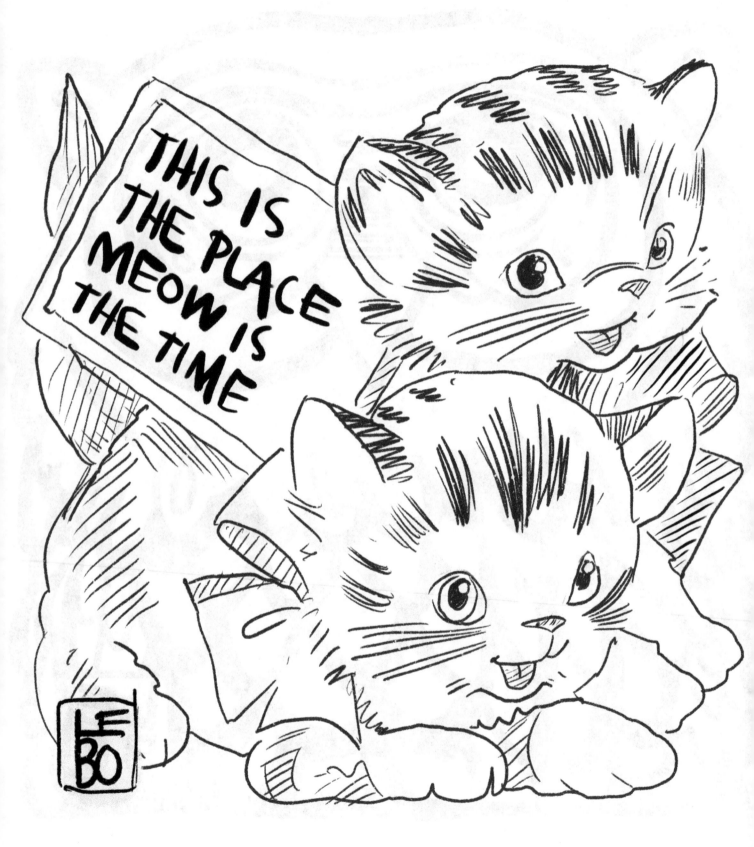

may the road
rise up to meet
you

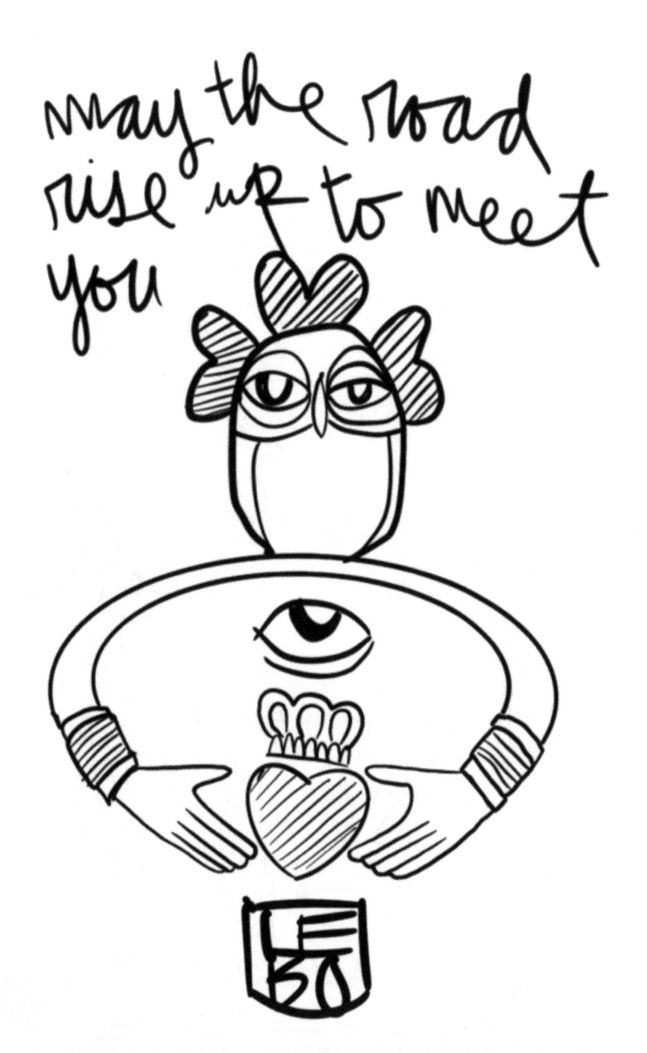

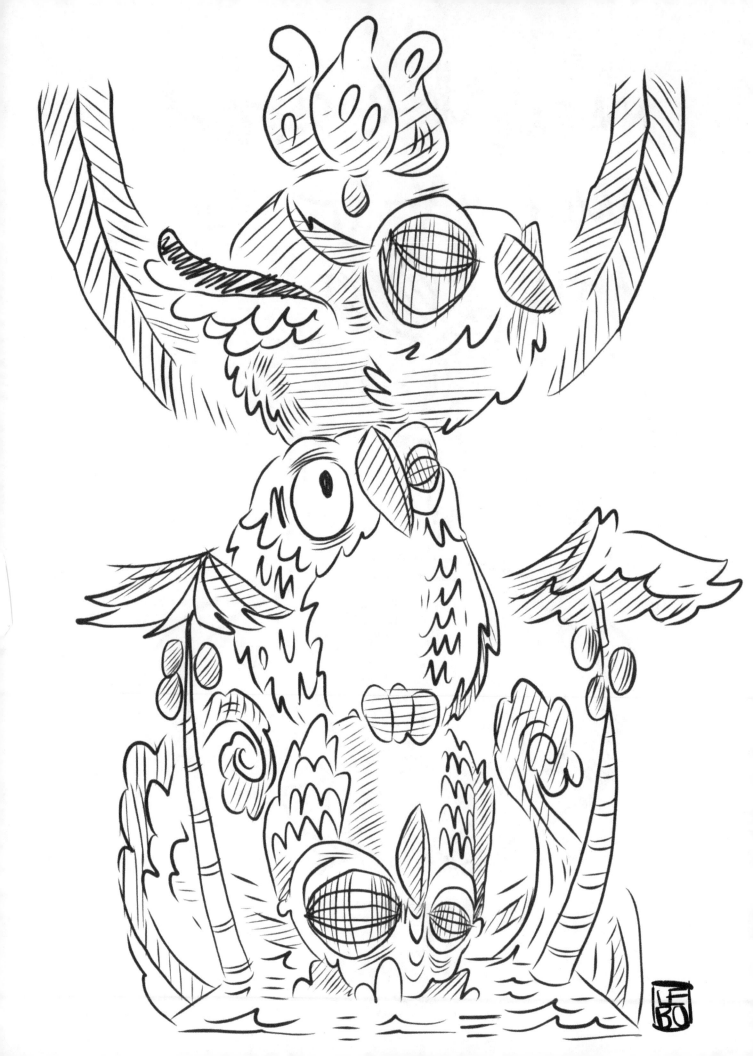

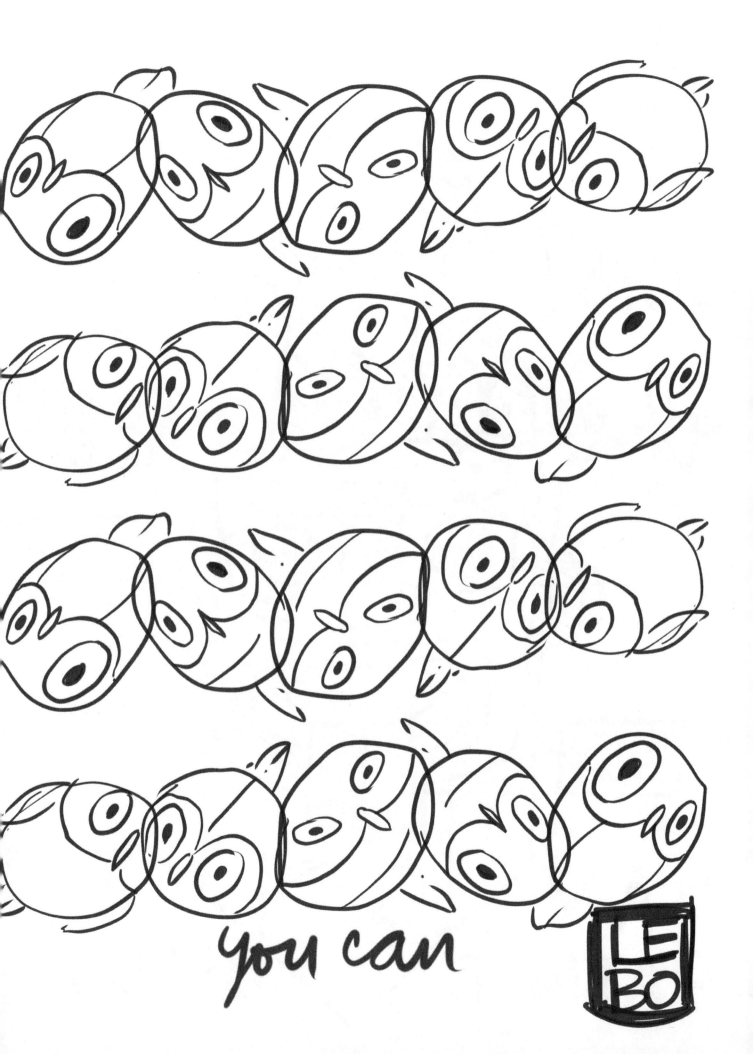

you can

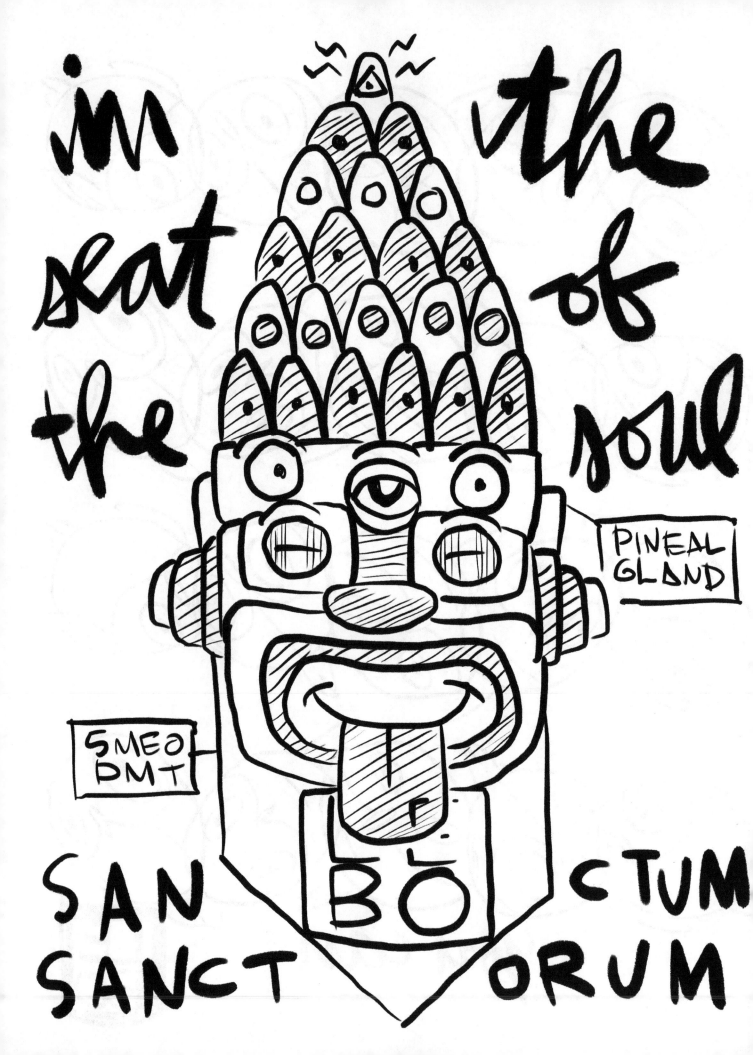

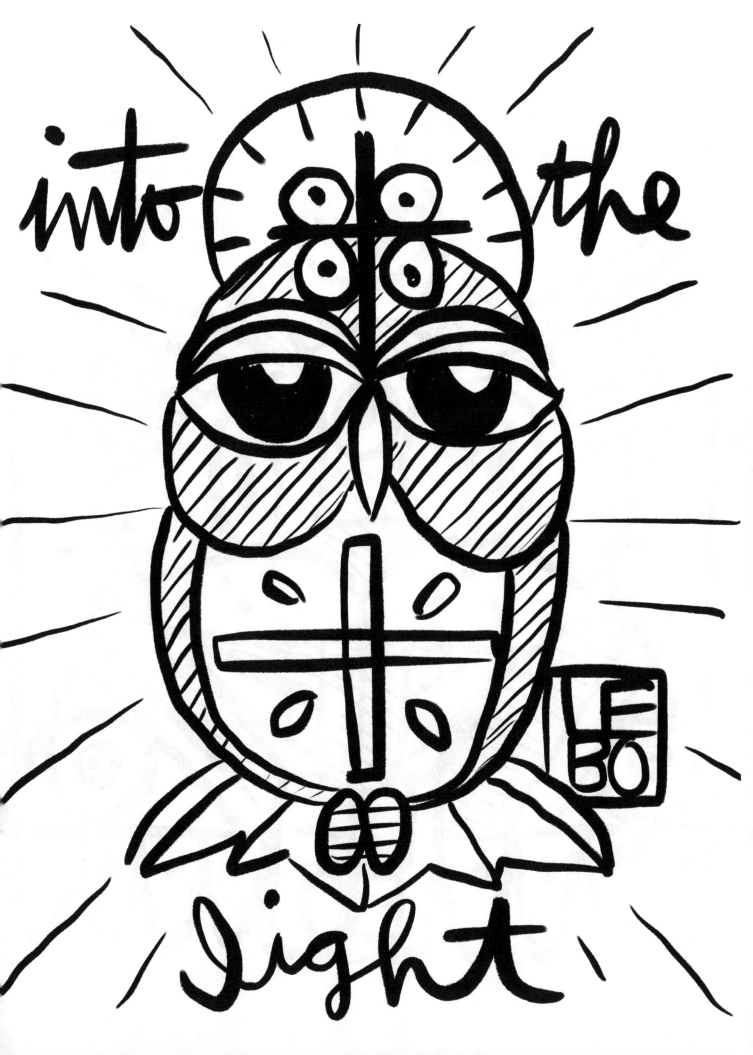

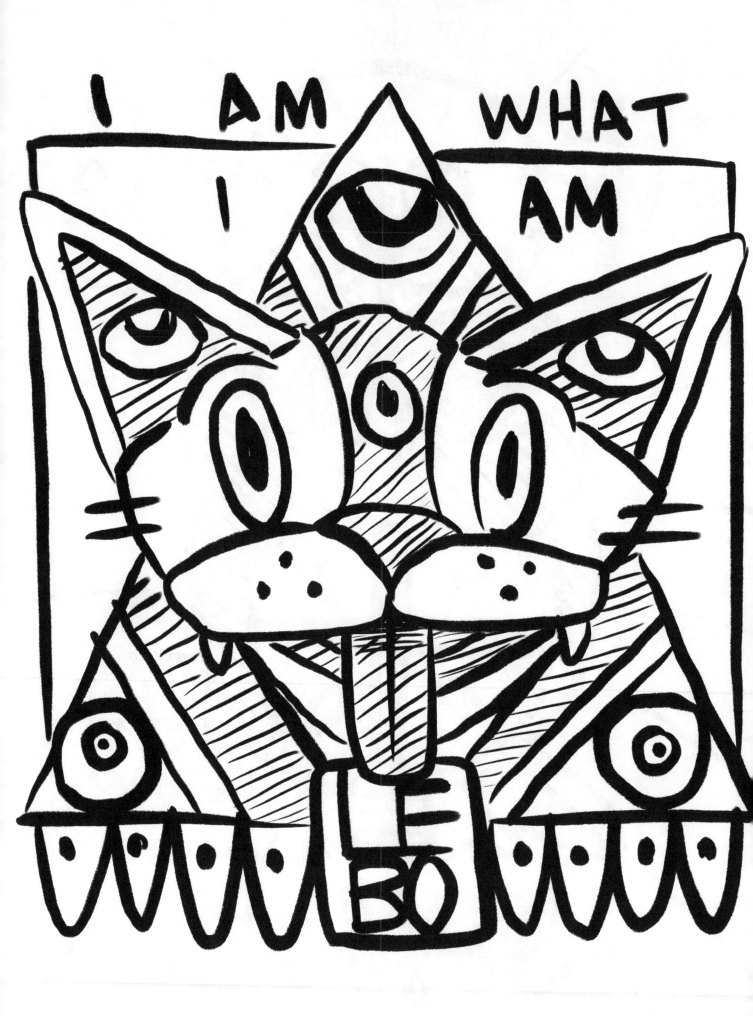

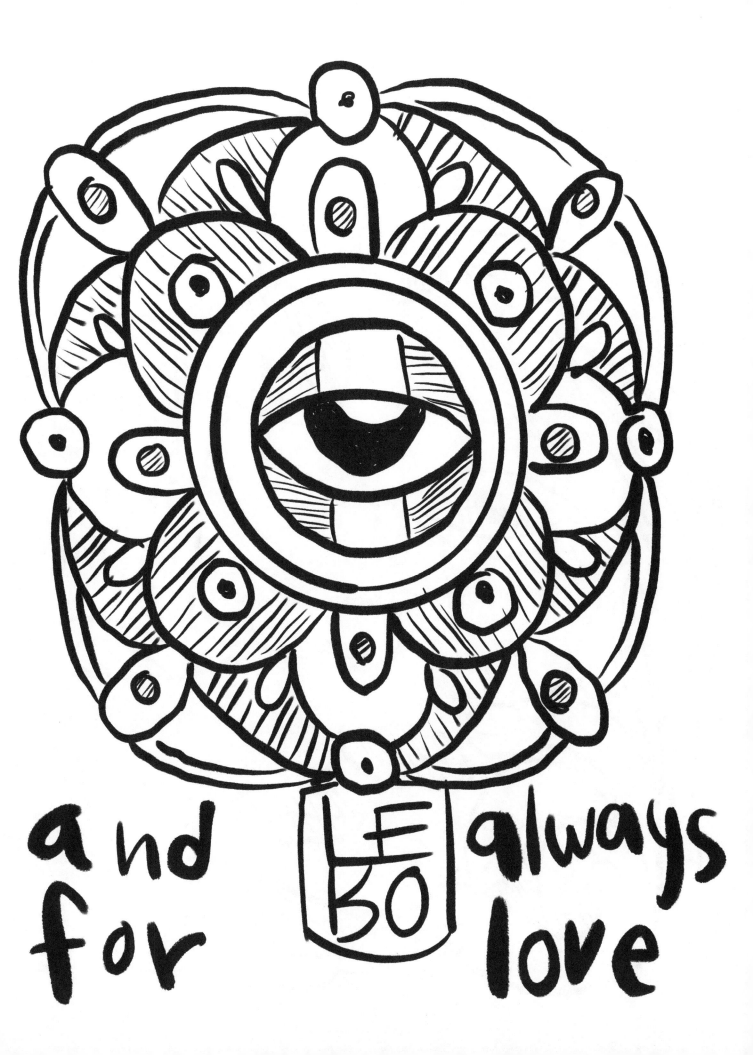

and for LEBO always love

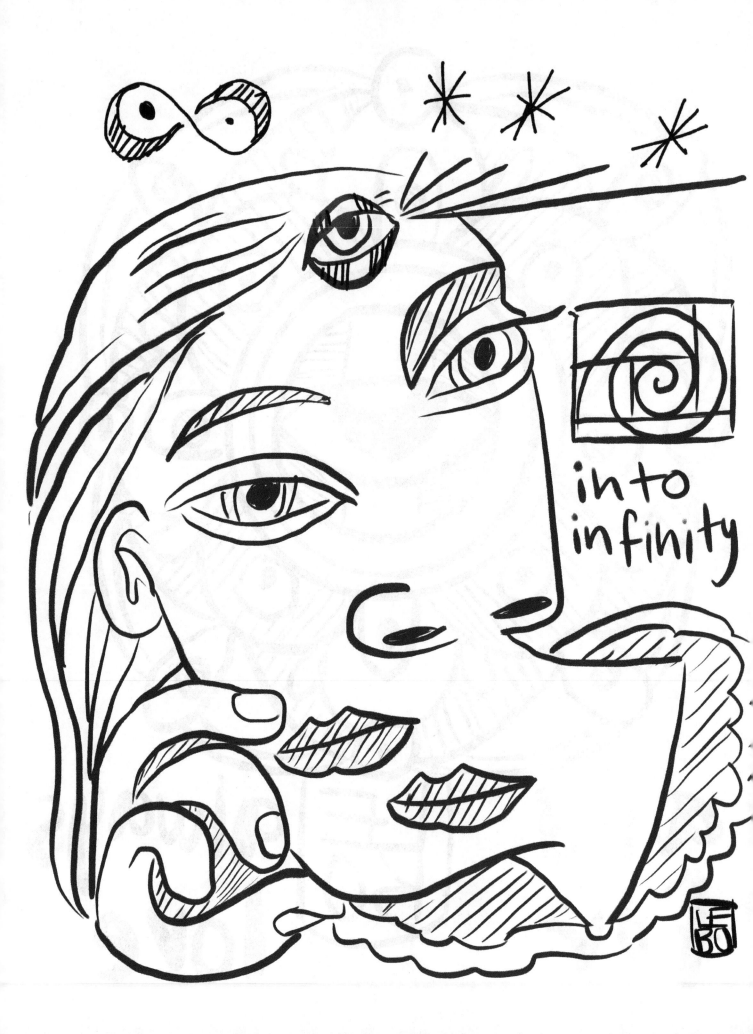

into
infinity

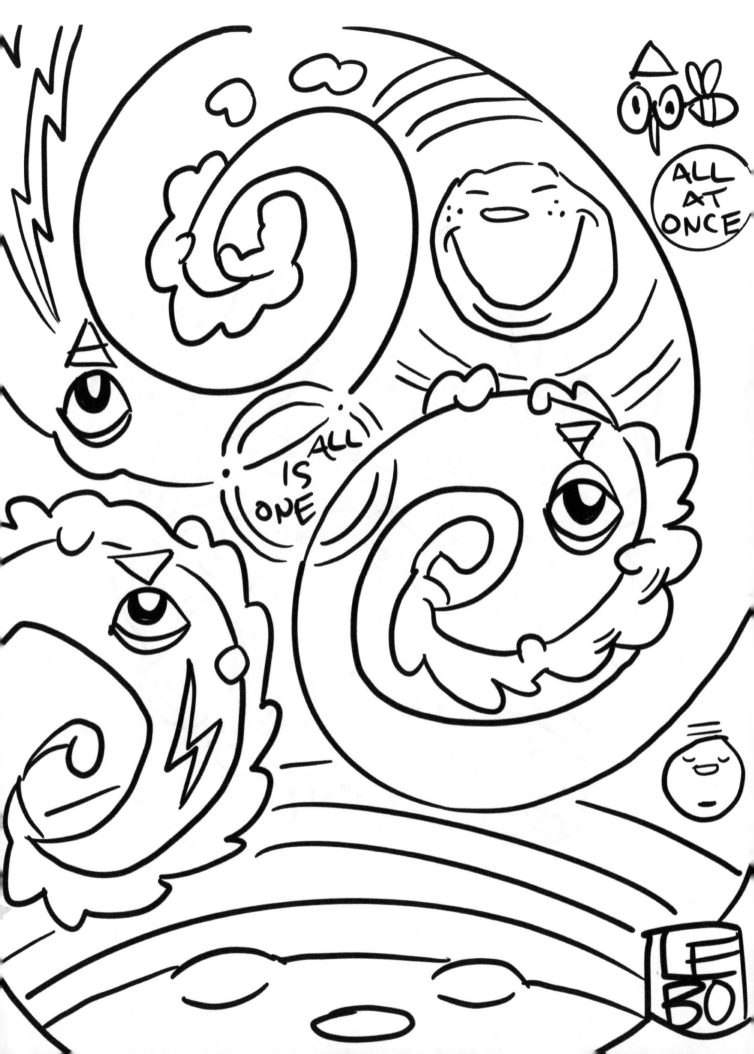

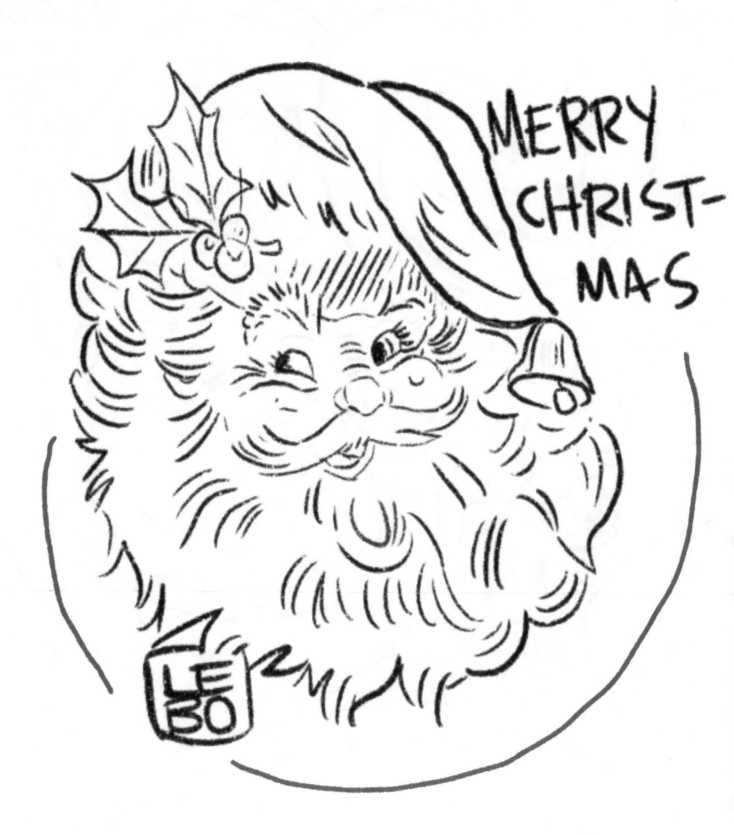

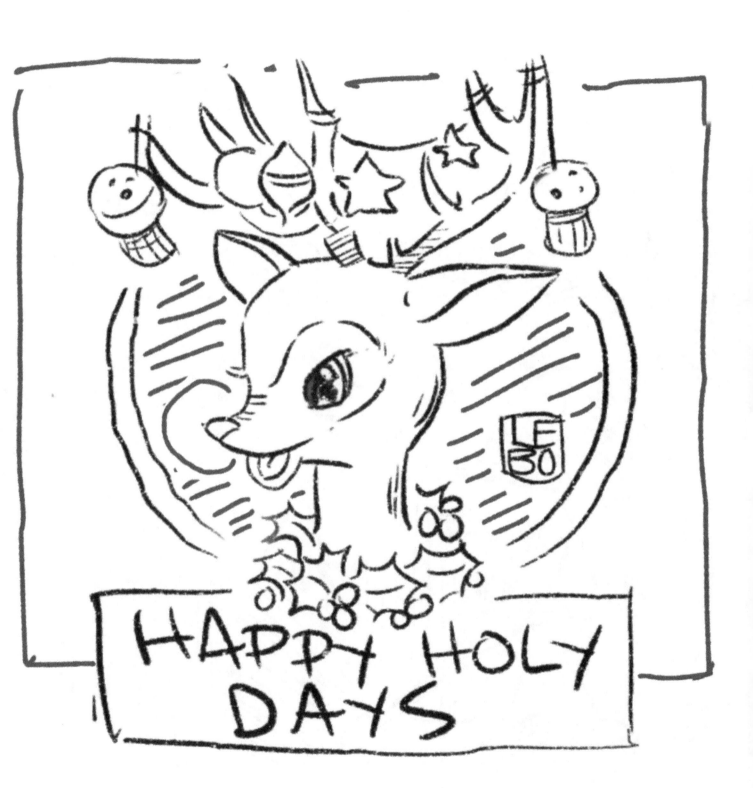

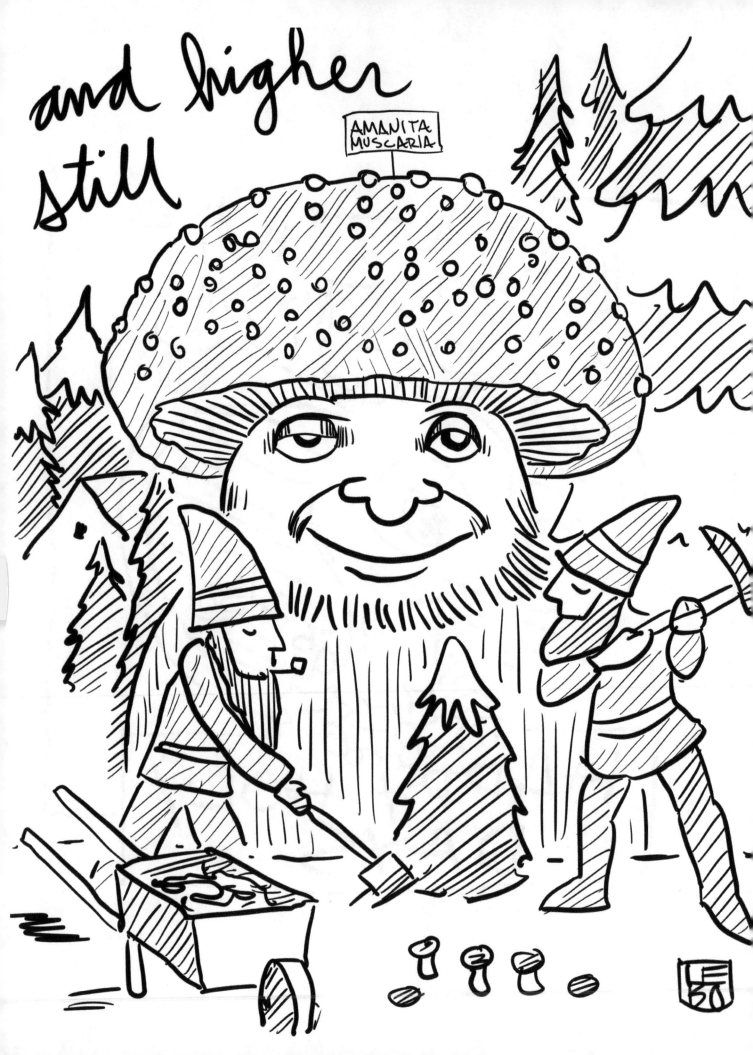

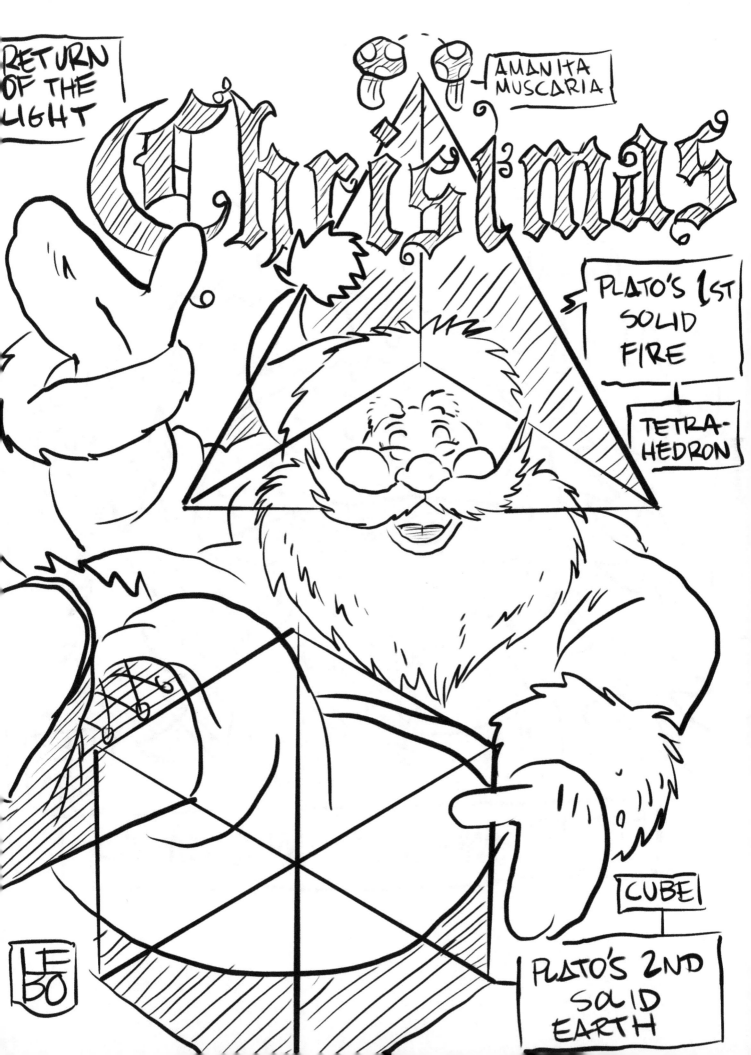

the reason for the season

FIG 08. amanita muscaria

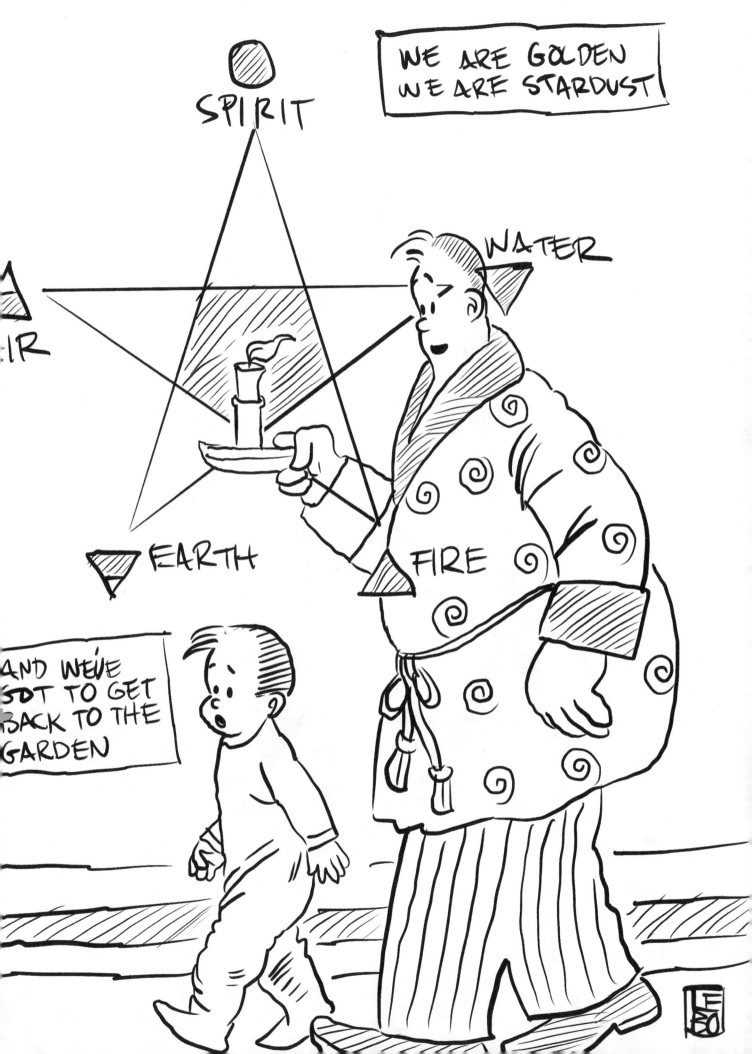

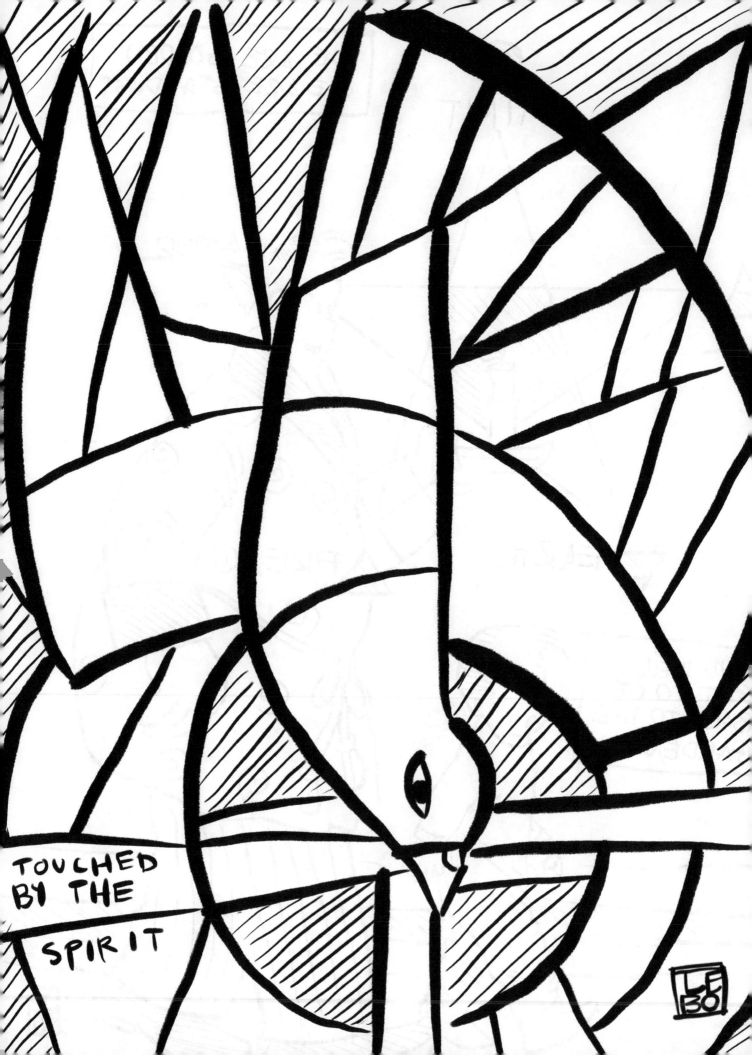

TOUCHED BY THE SPIRIT

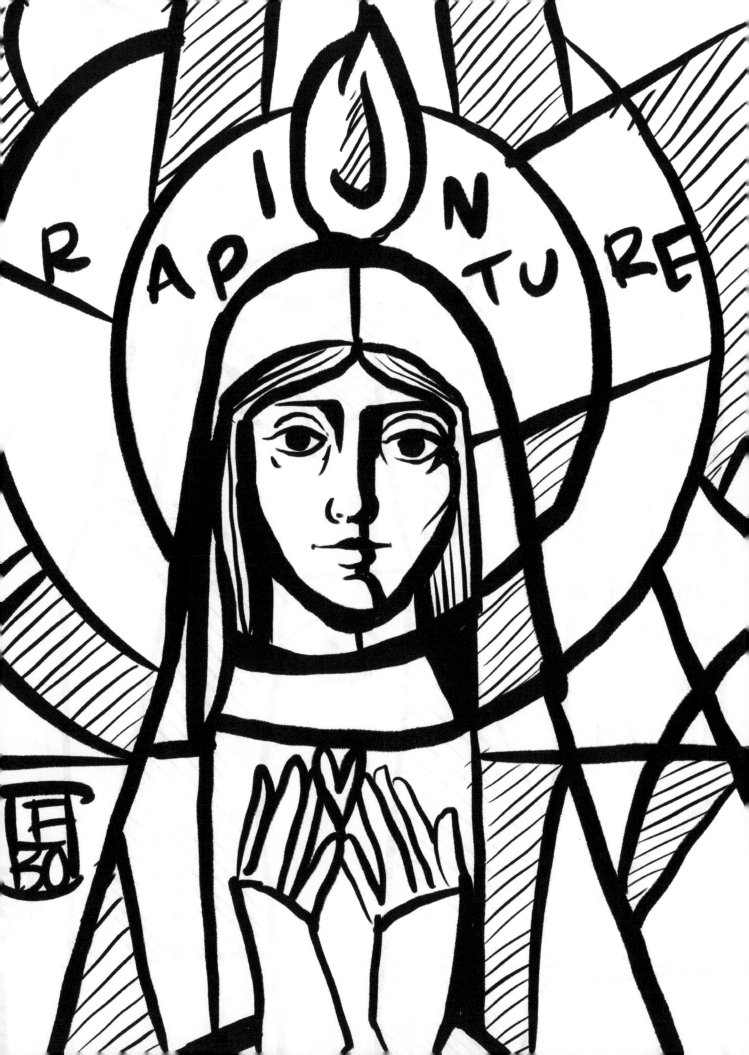

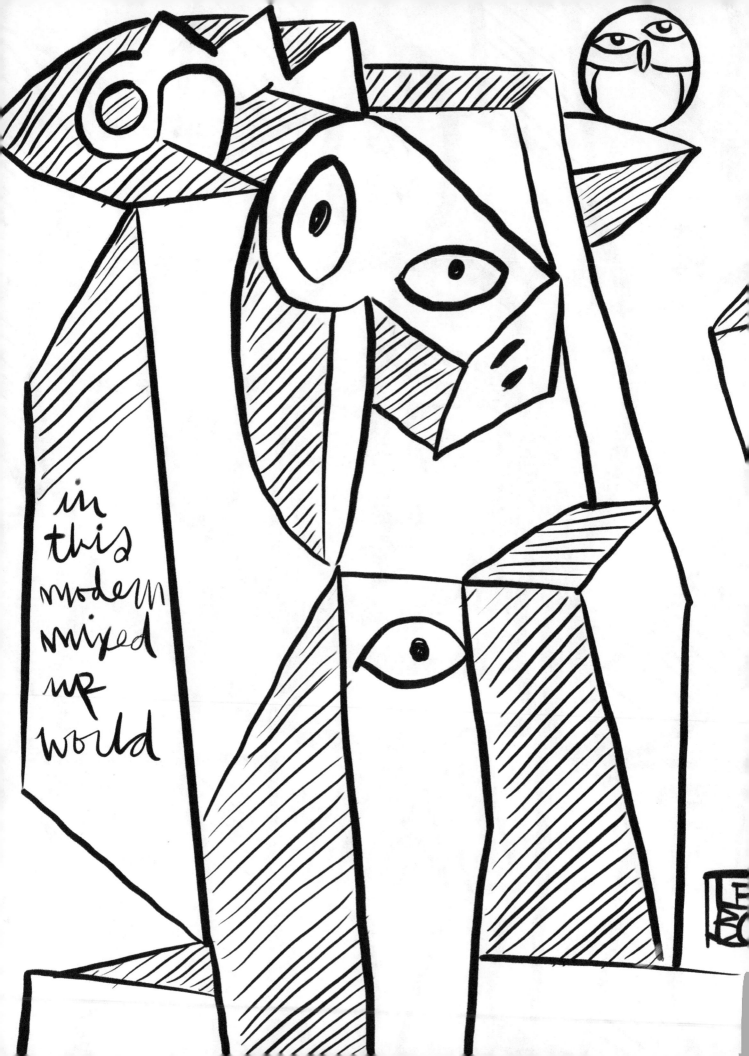

in this
modern
mixed
up
world

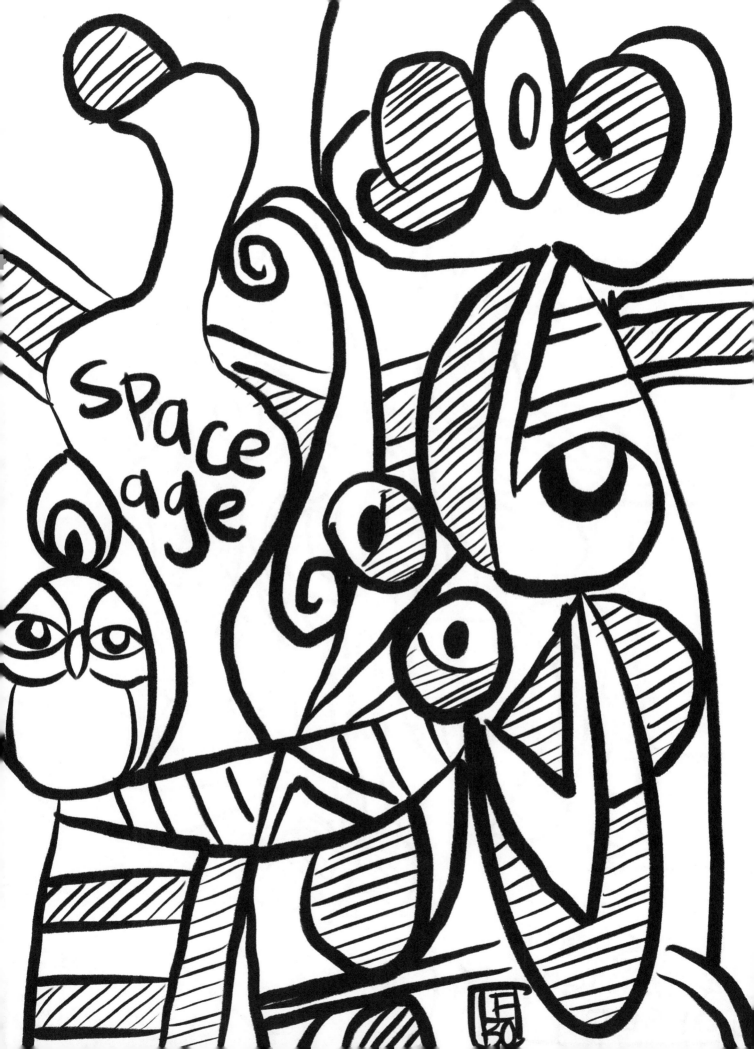

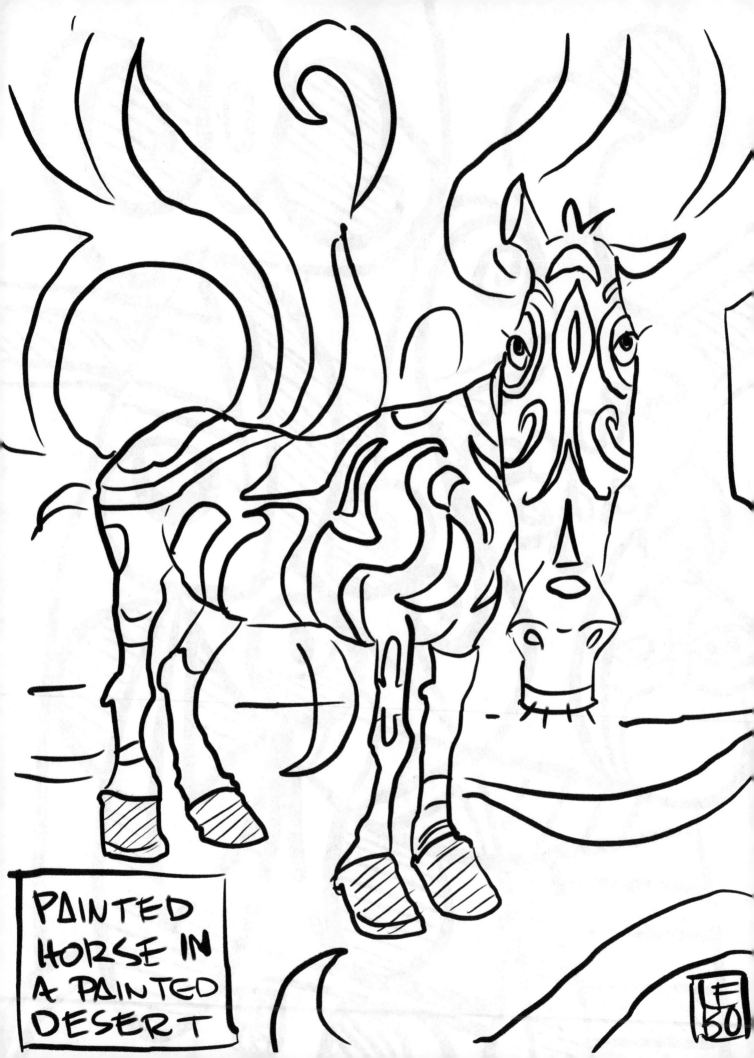

PAINTED
HORSE IN
A PAINTED
DESERT

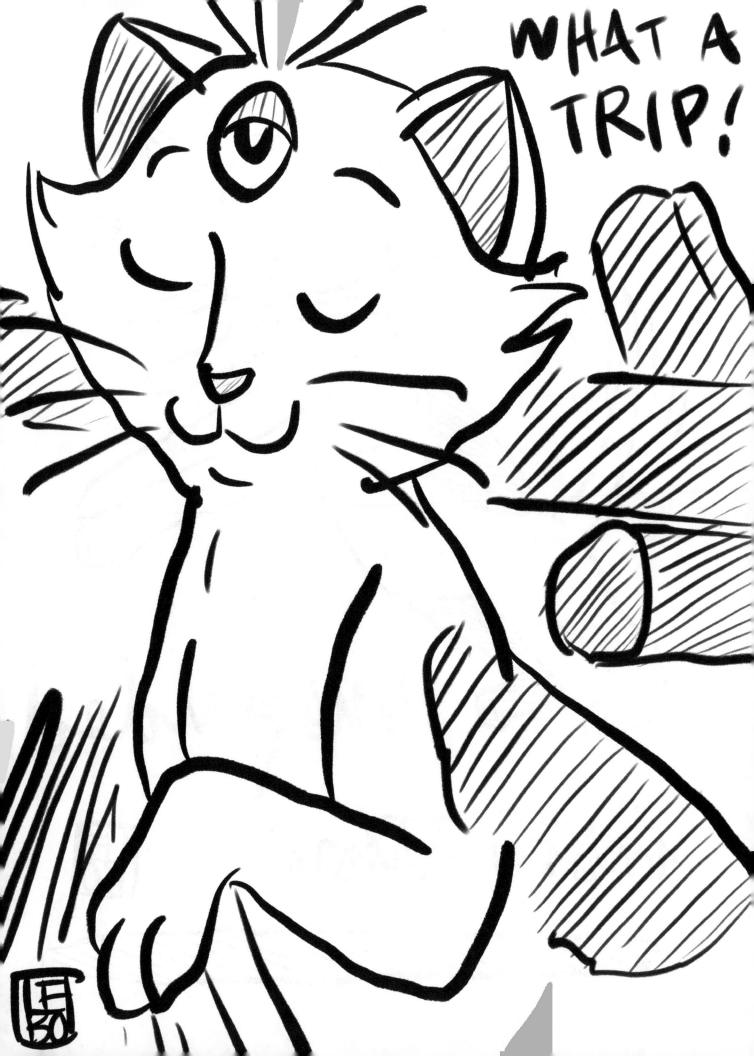

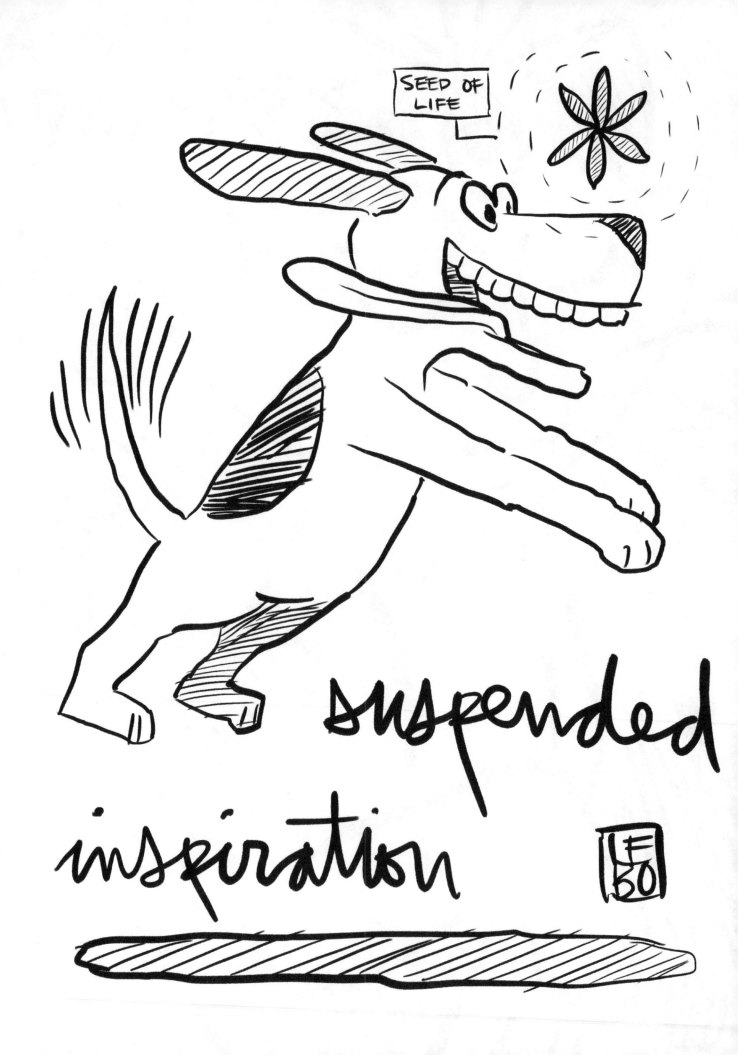

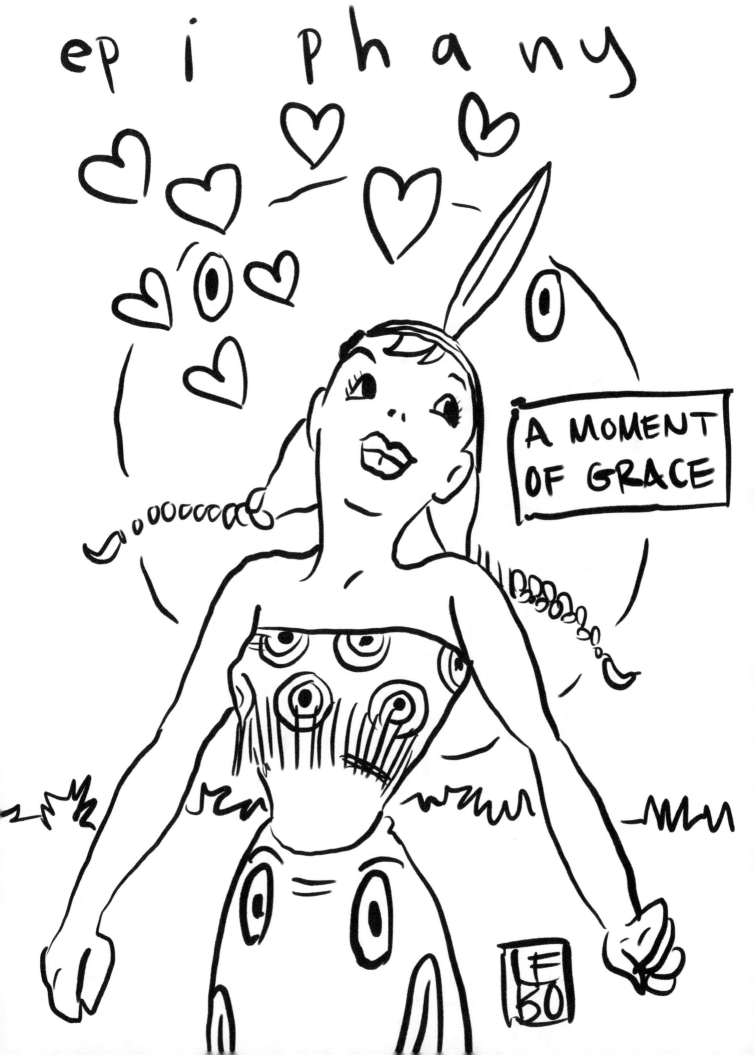

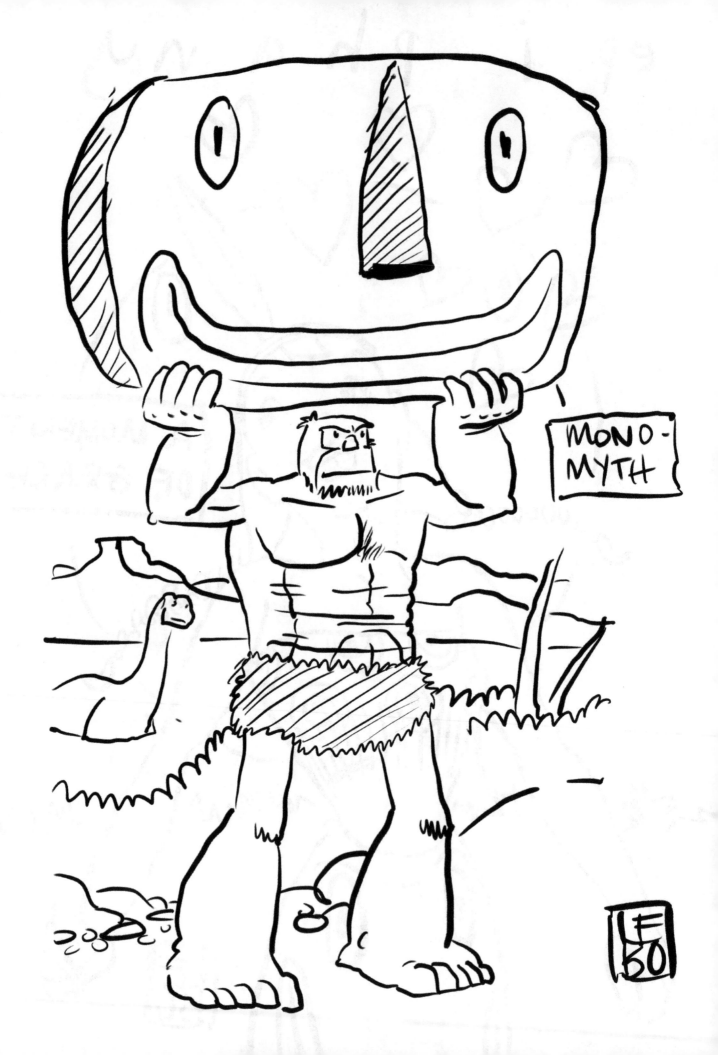

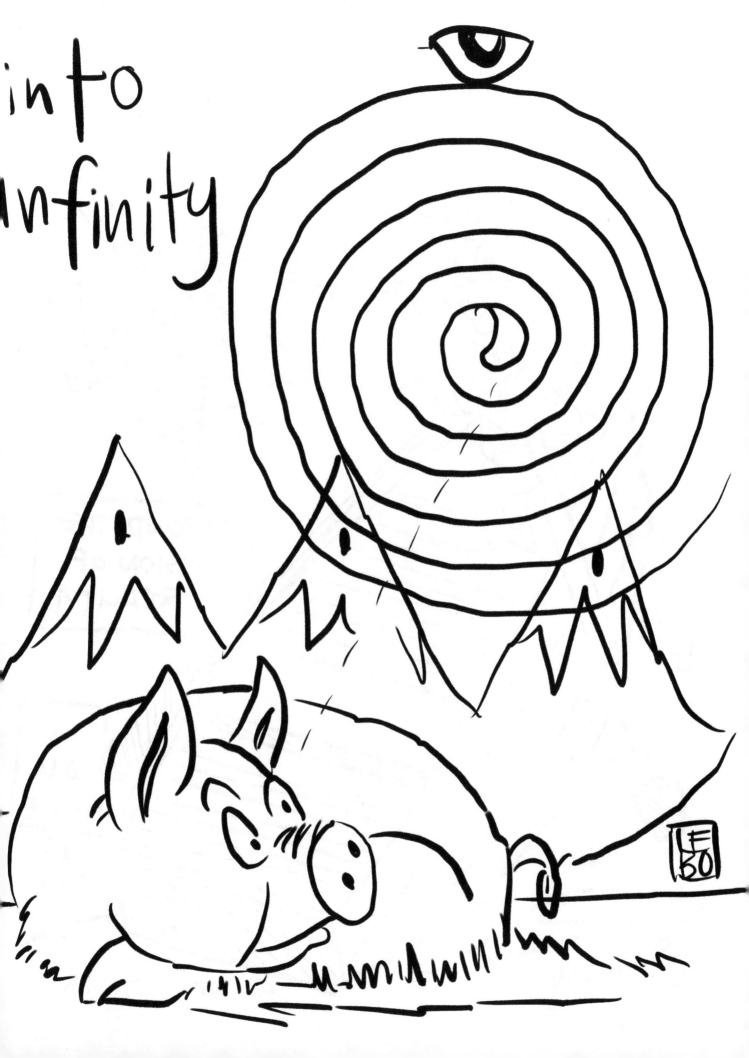

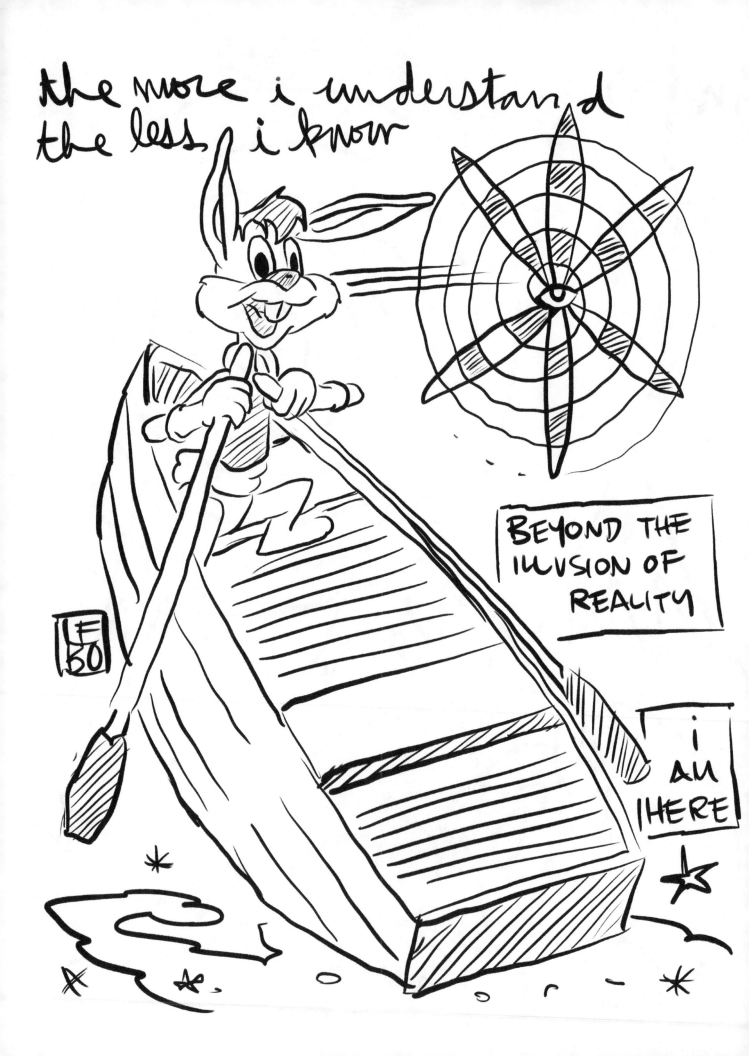

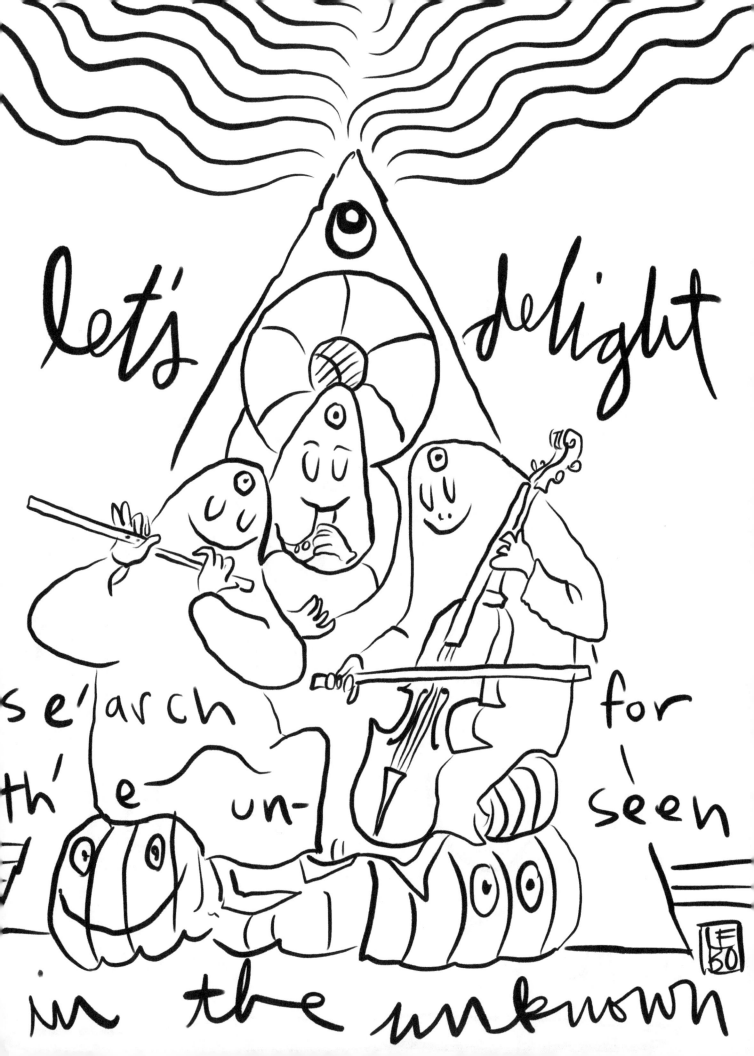

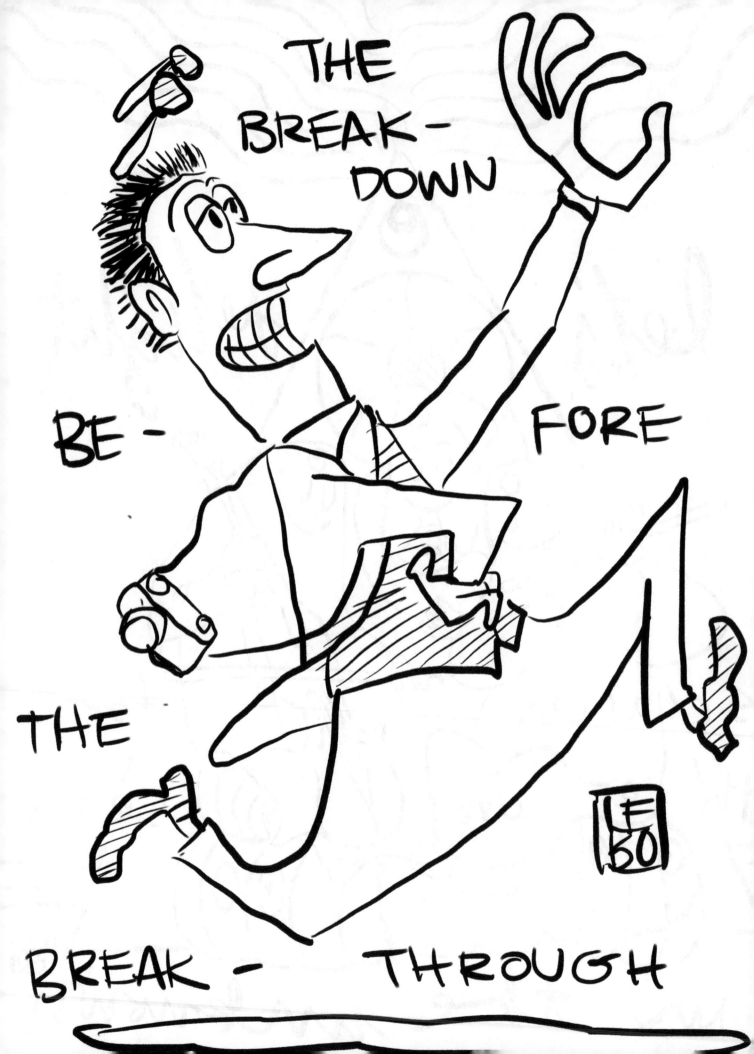

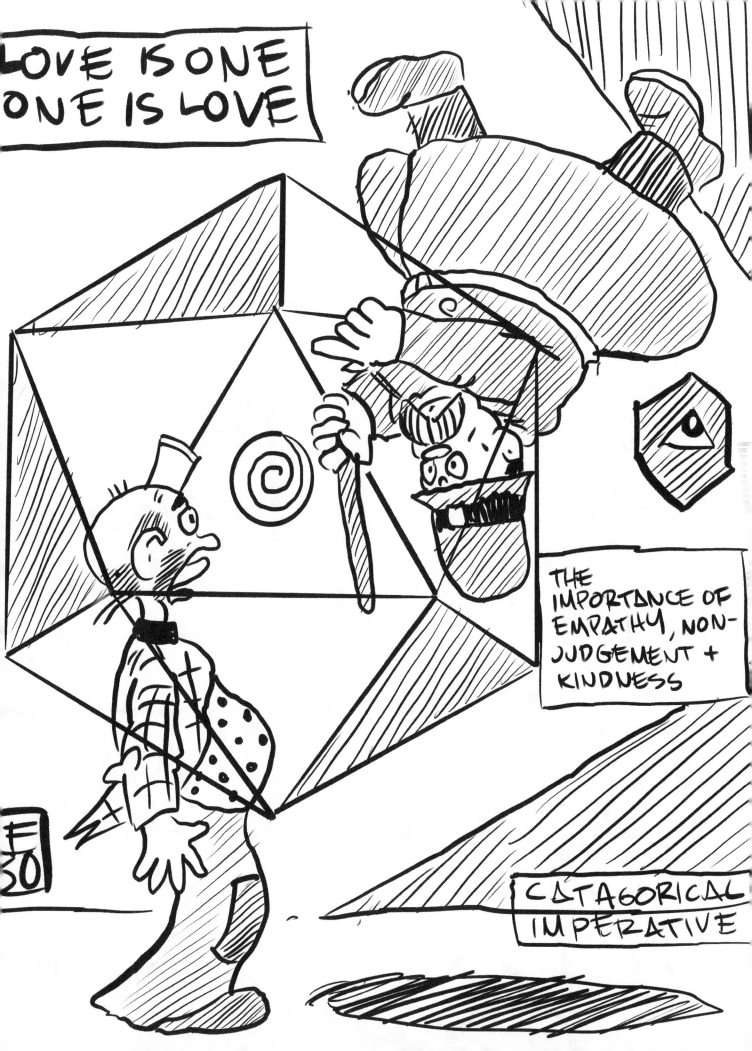

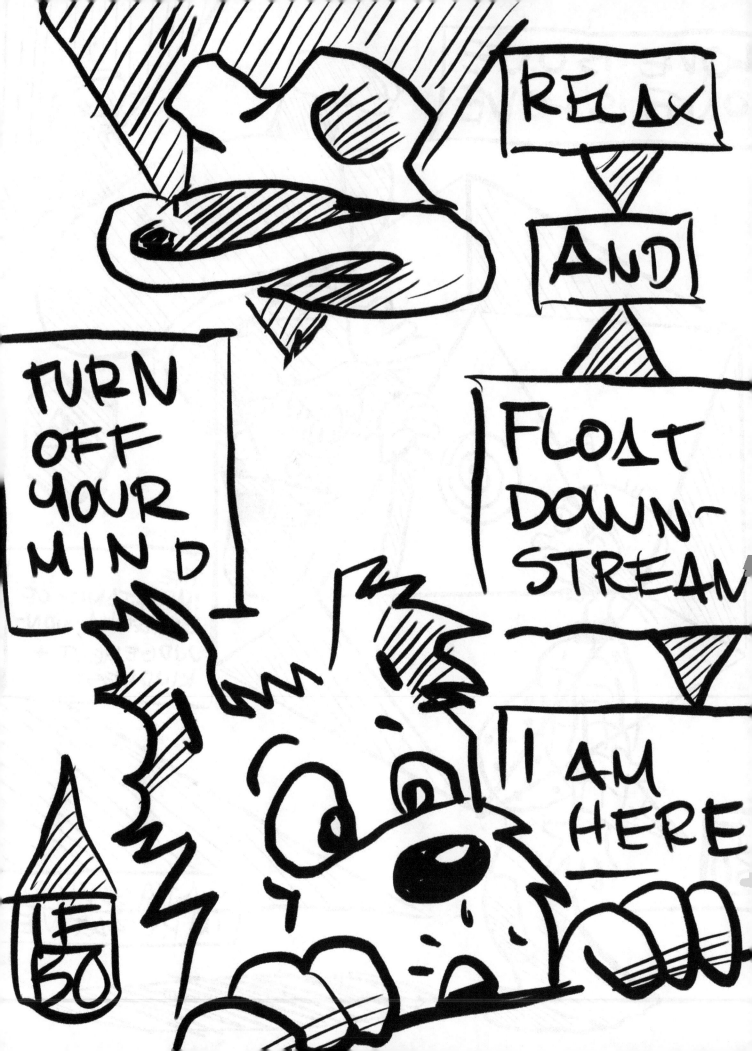

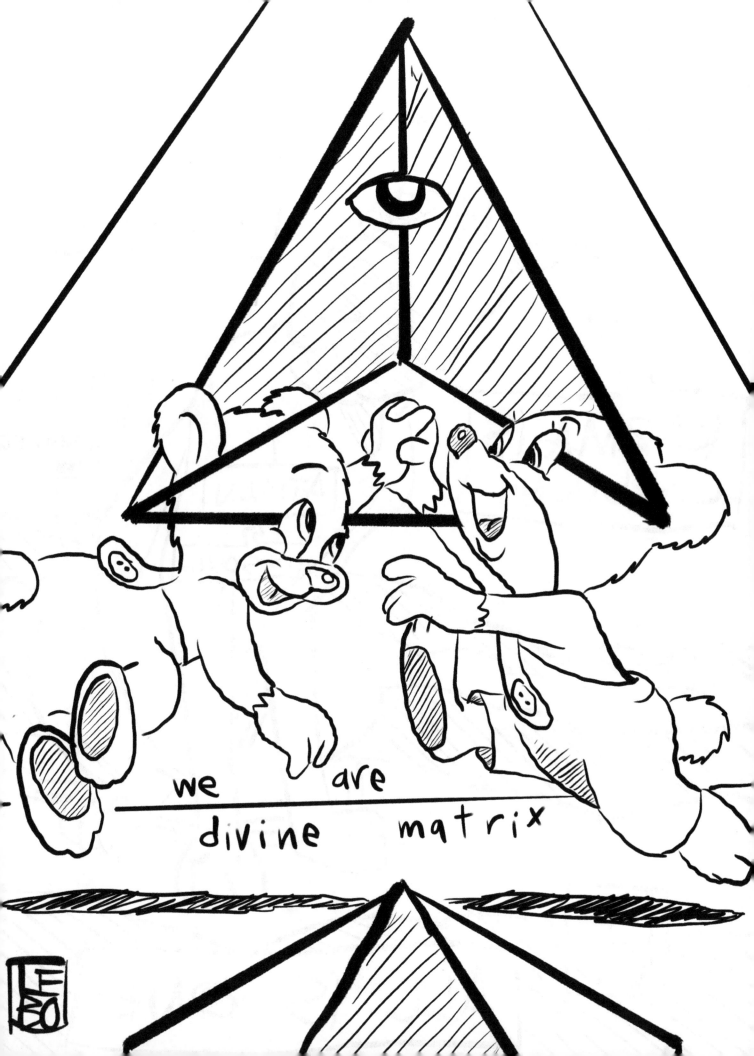

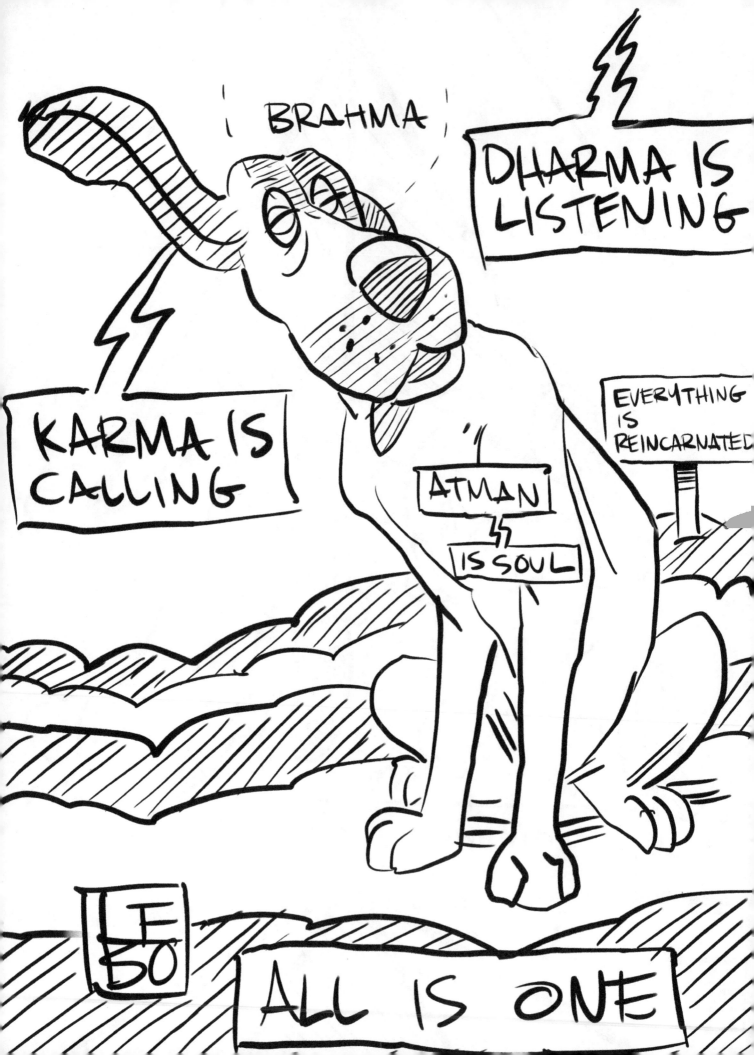

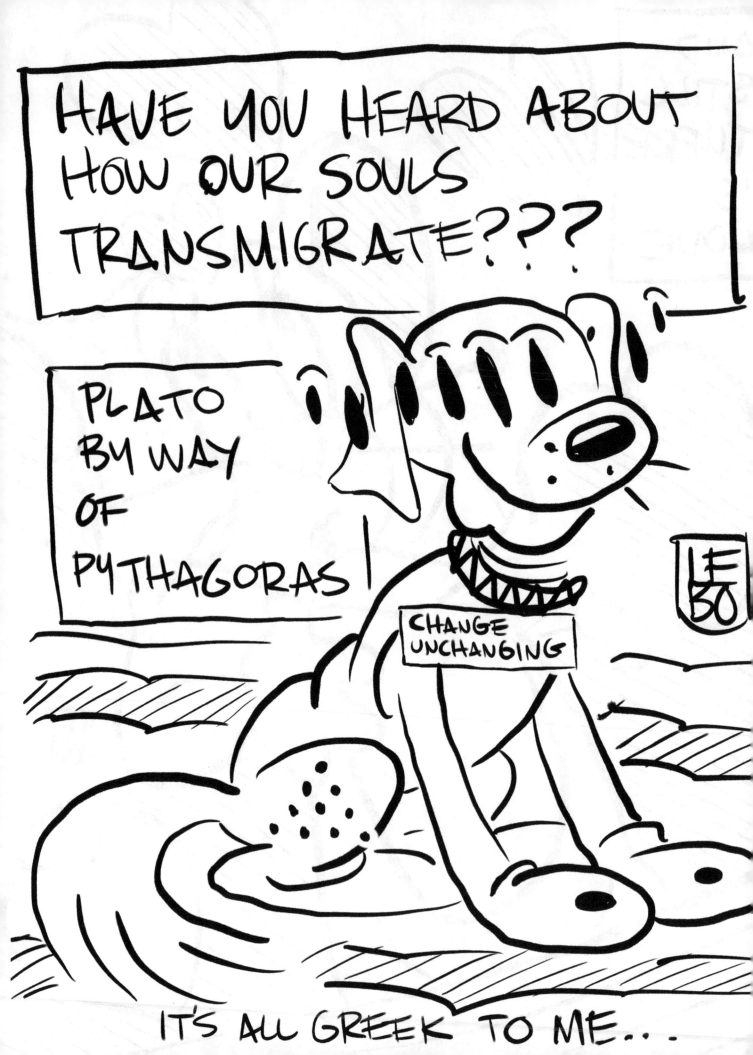

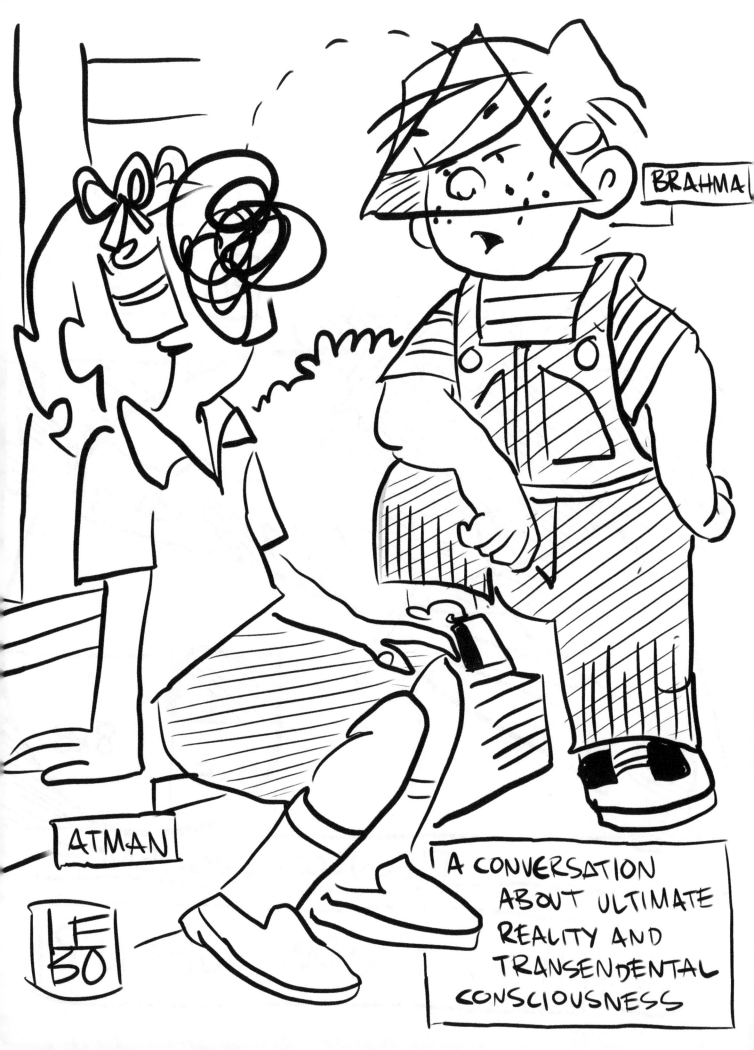

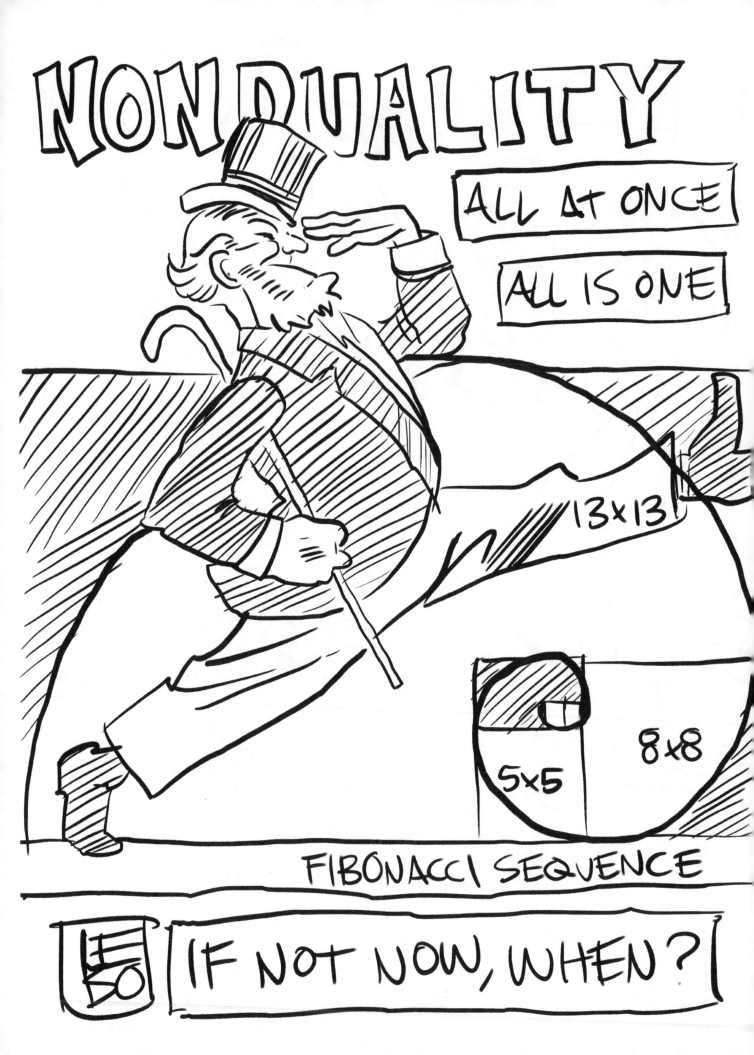

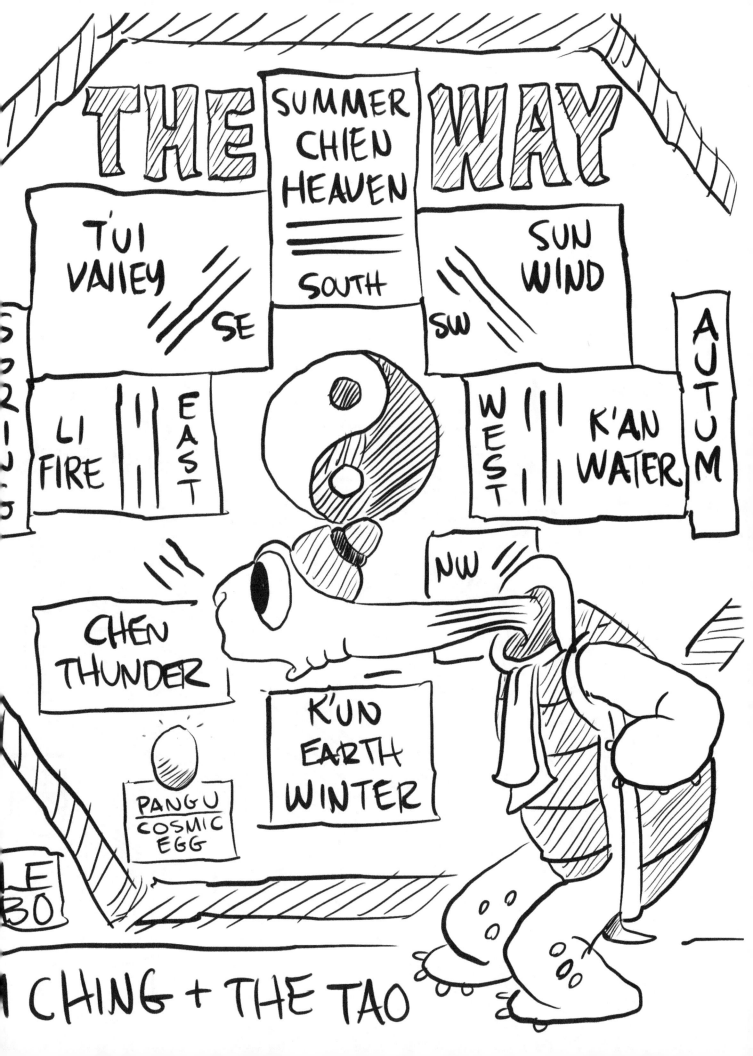

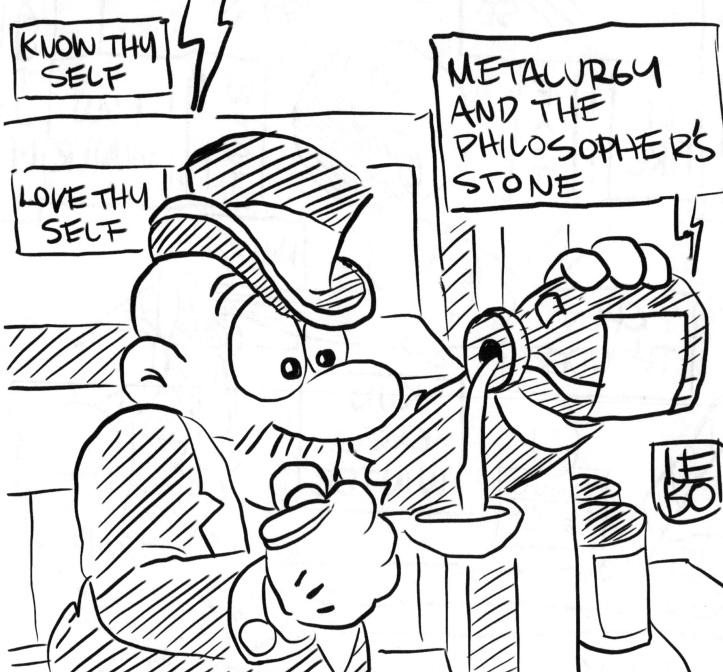

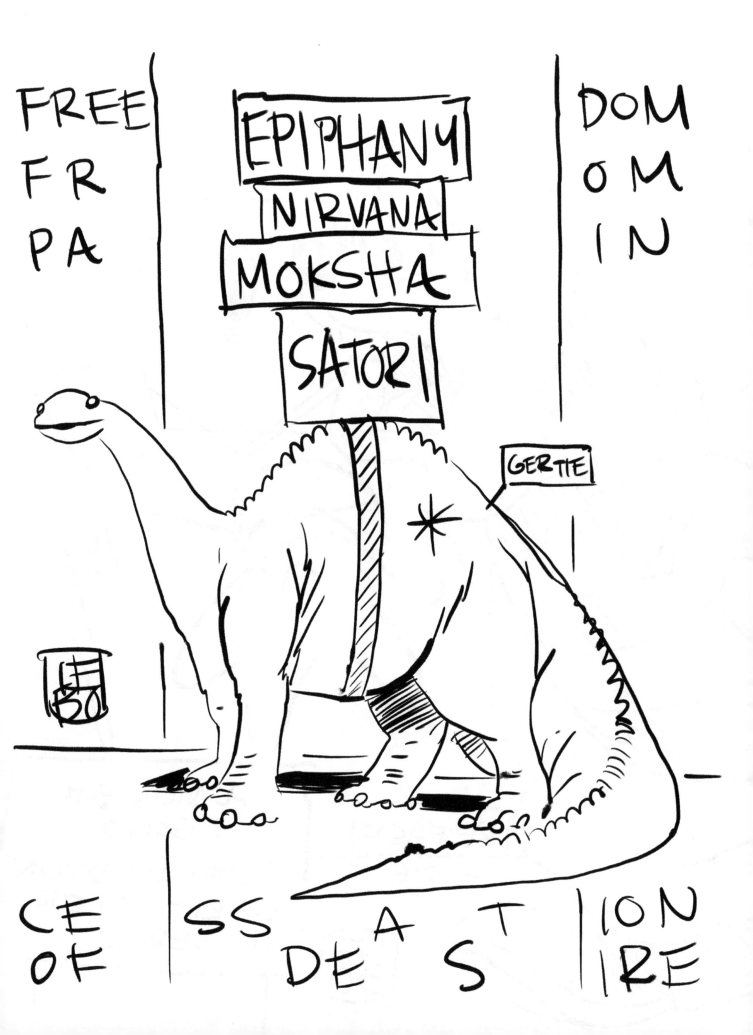

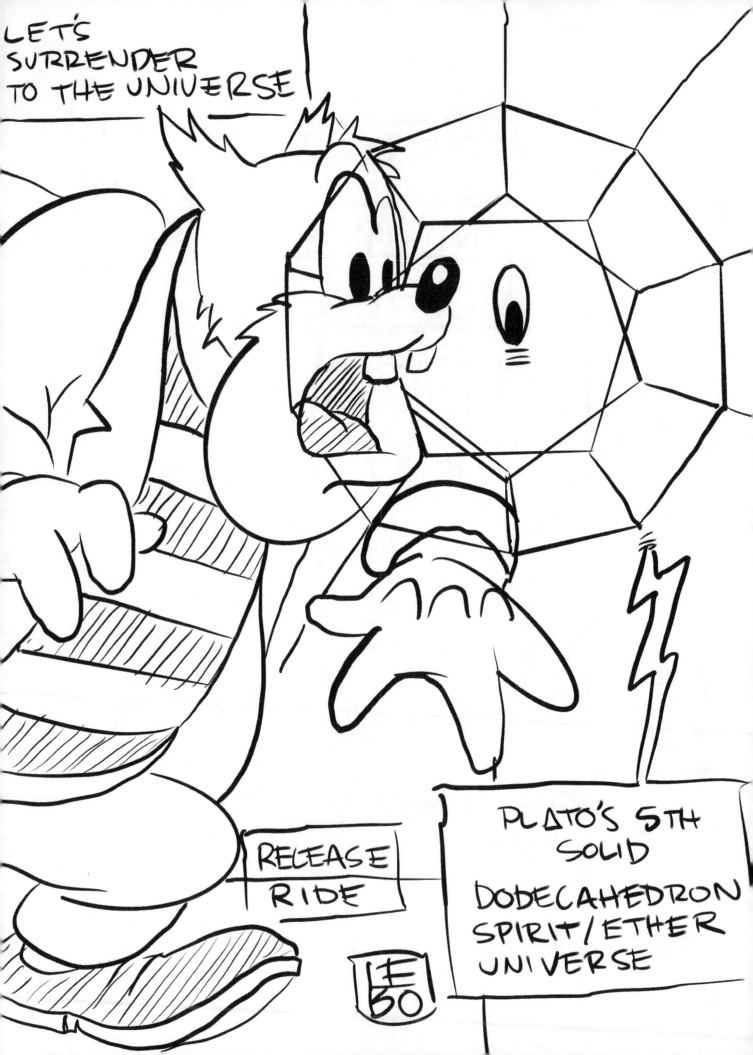

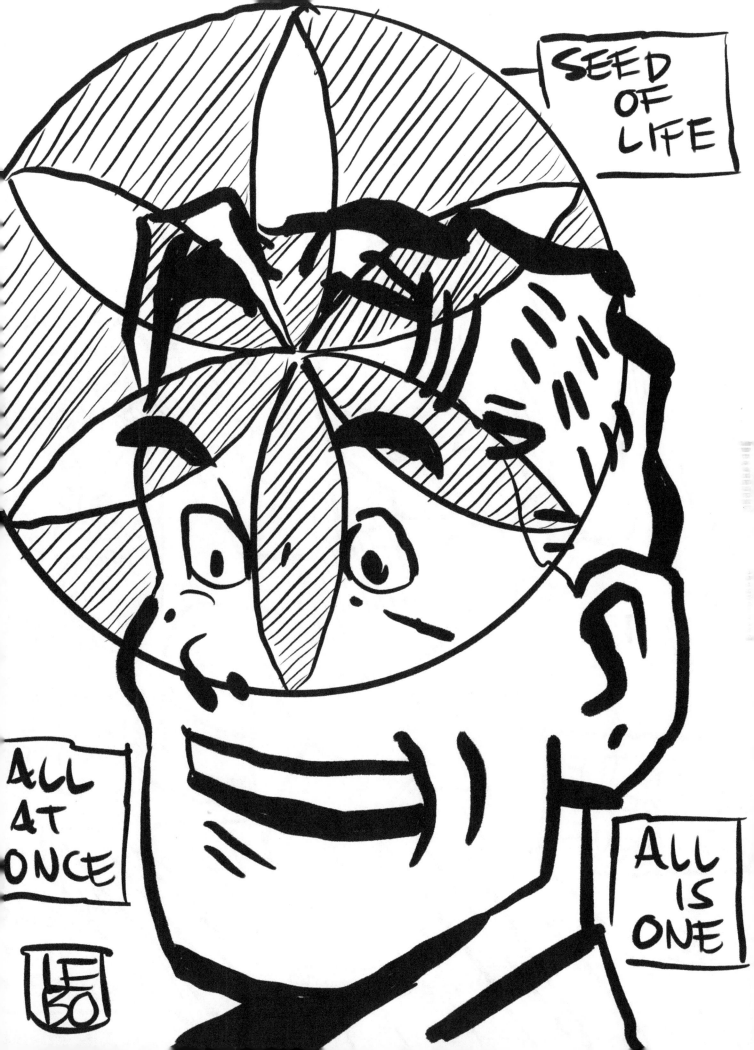

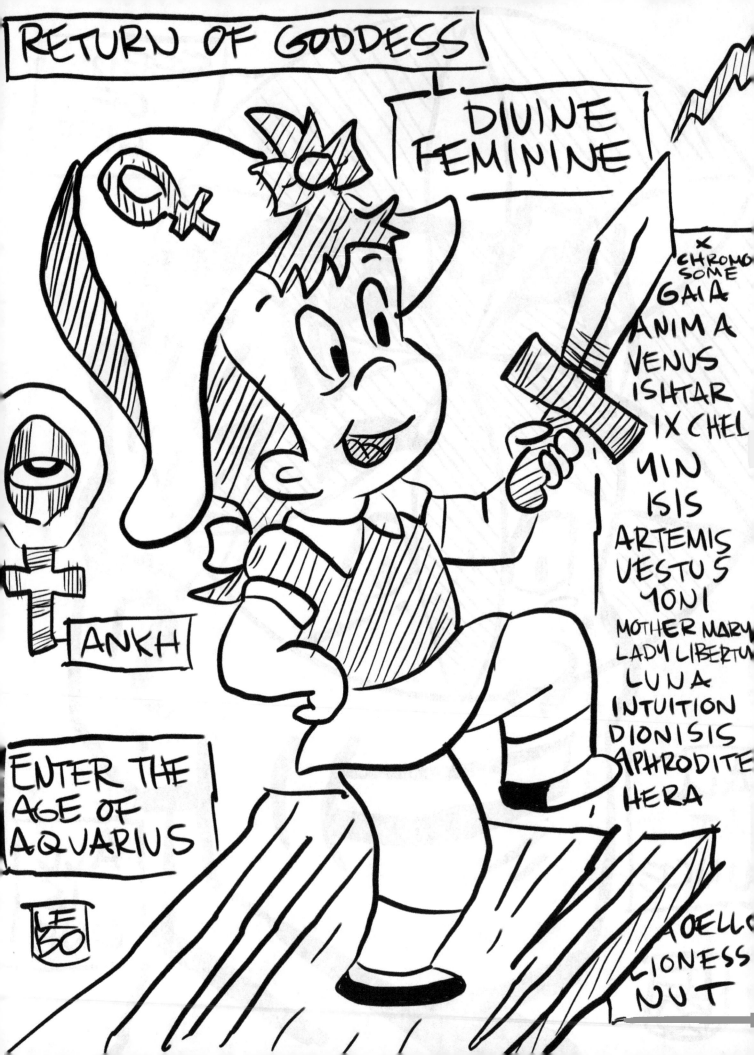

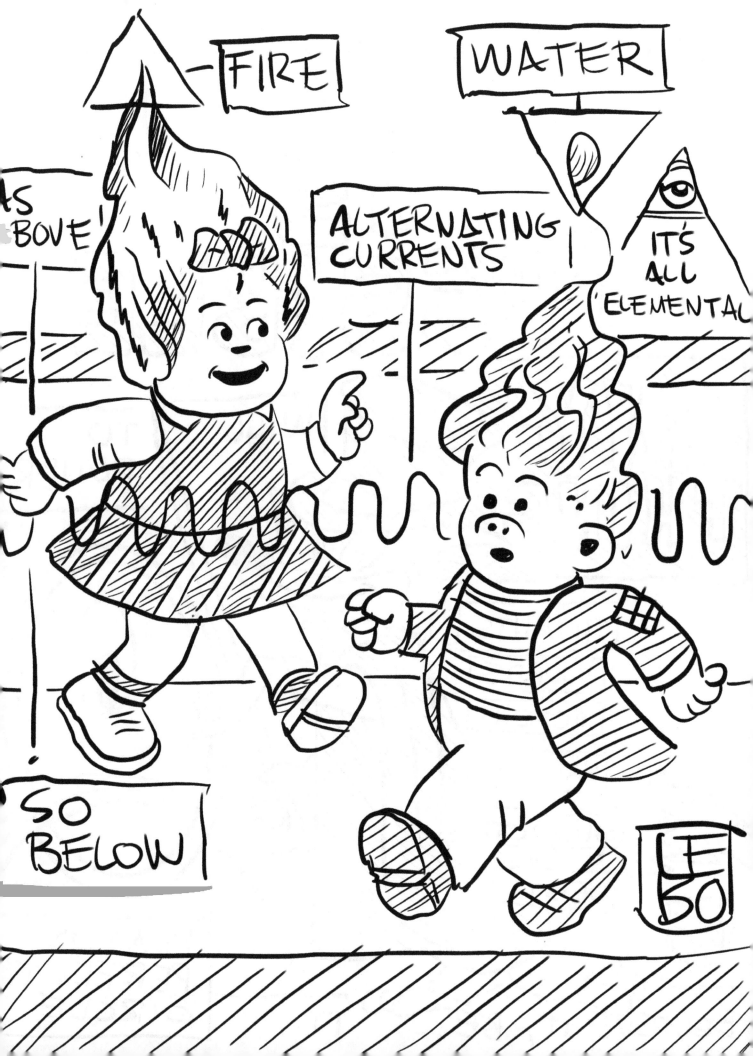

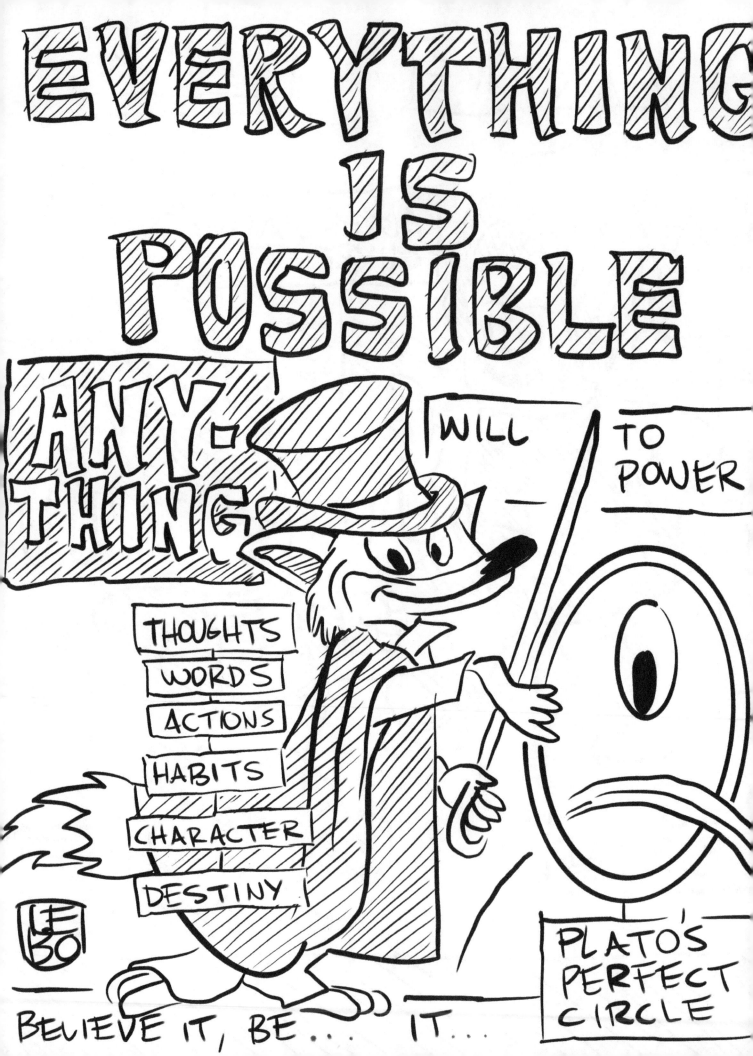

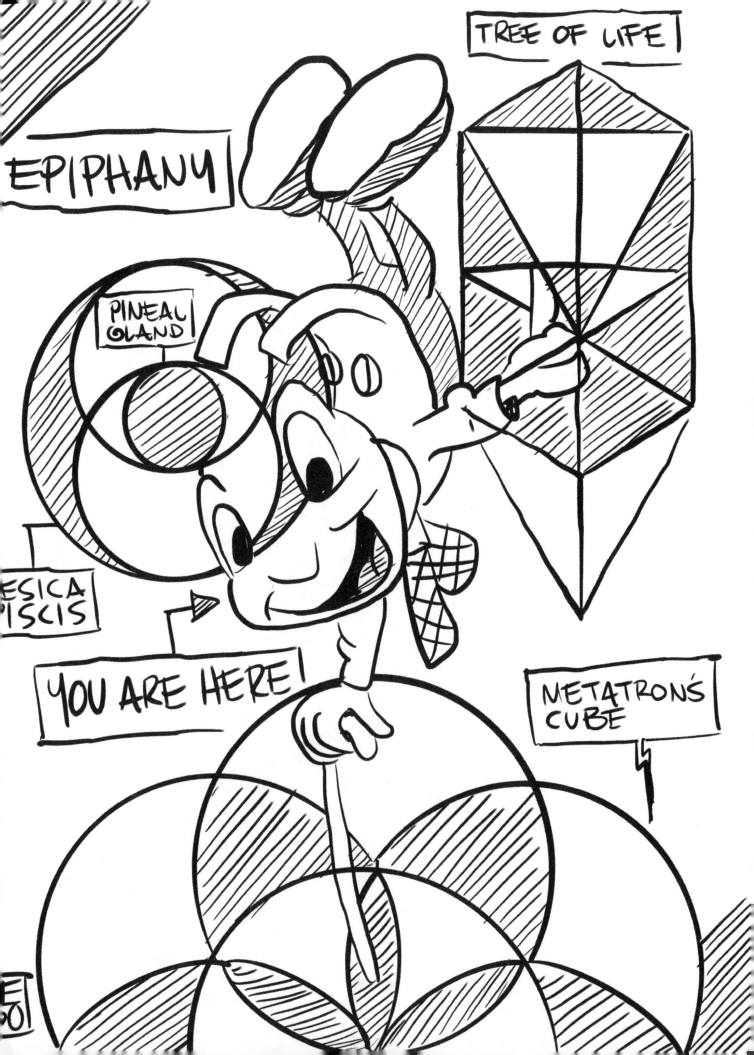

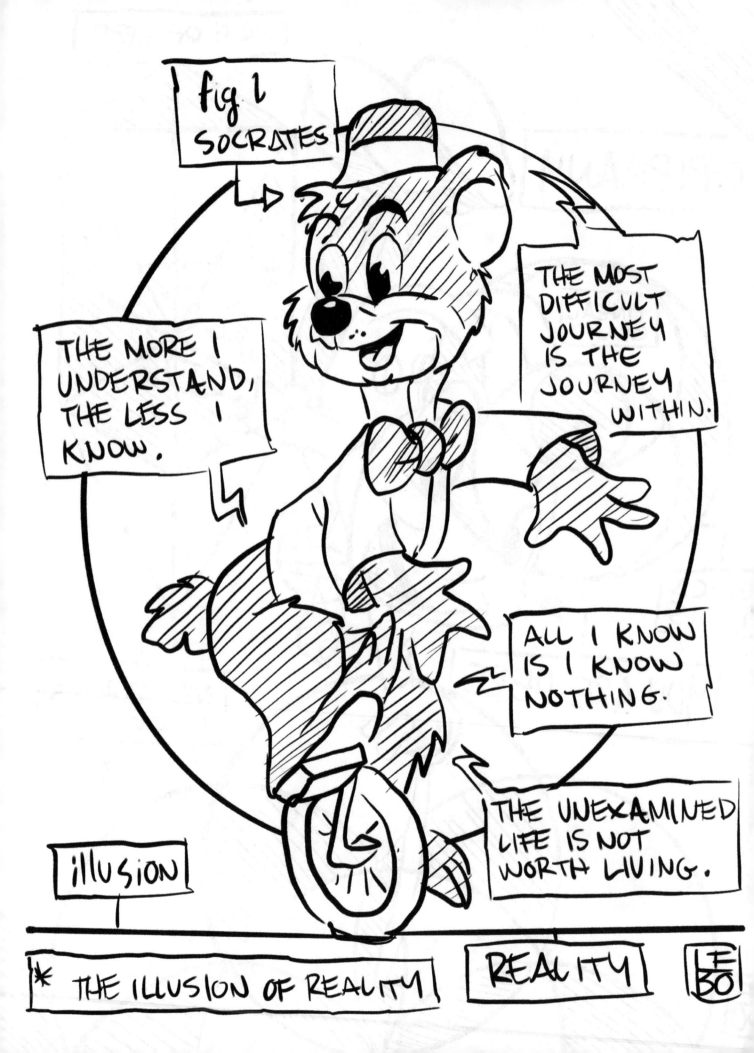

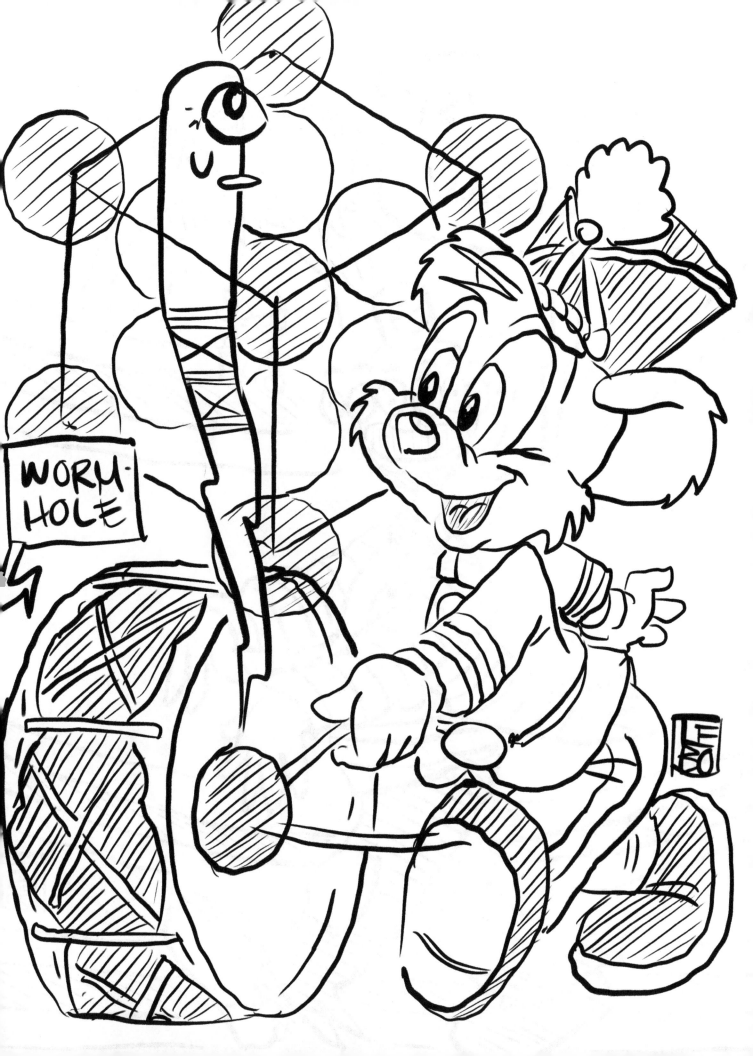

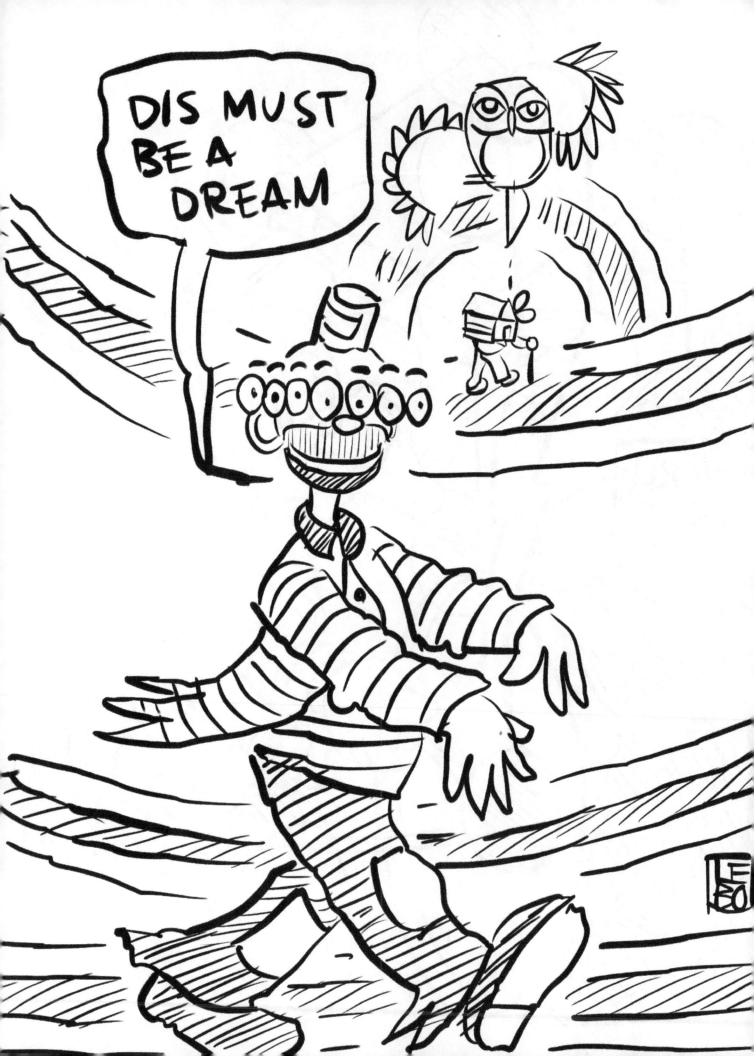

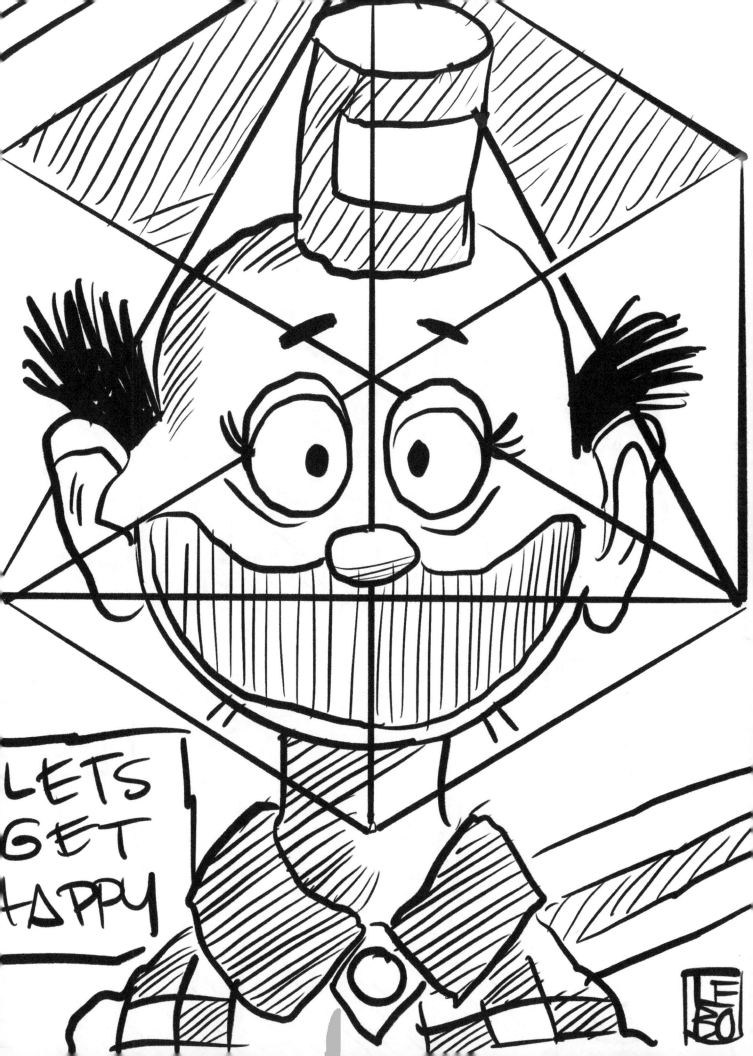

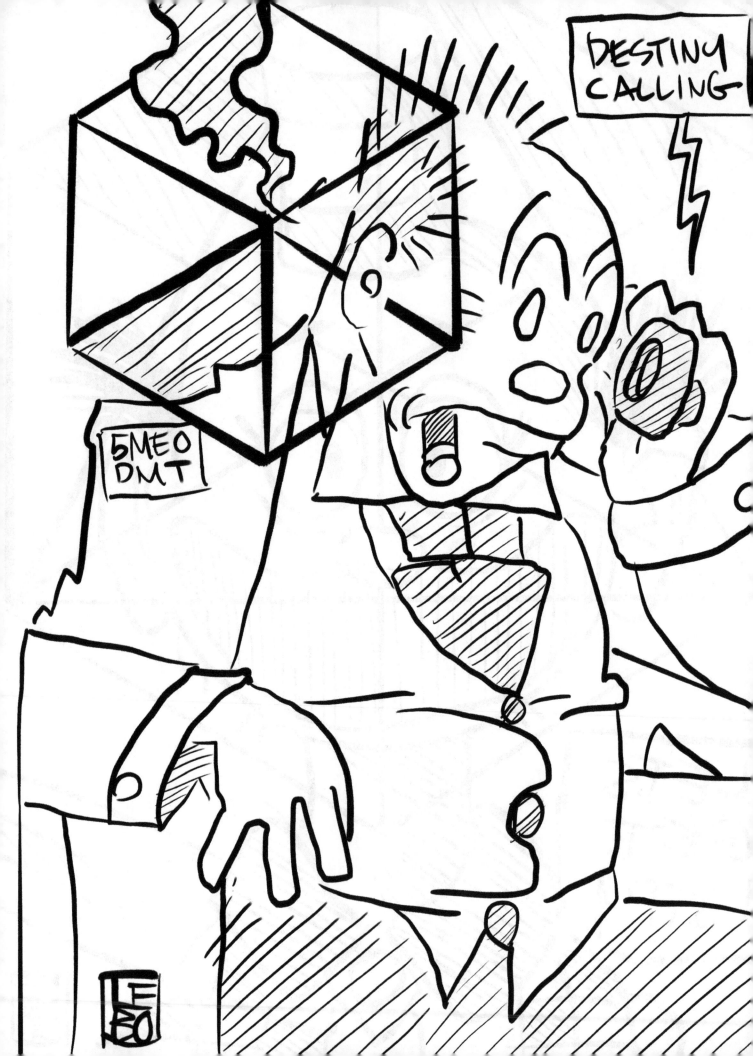

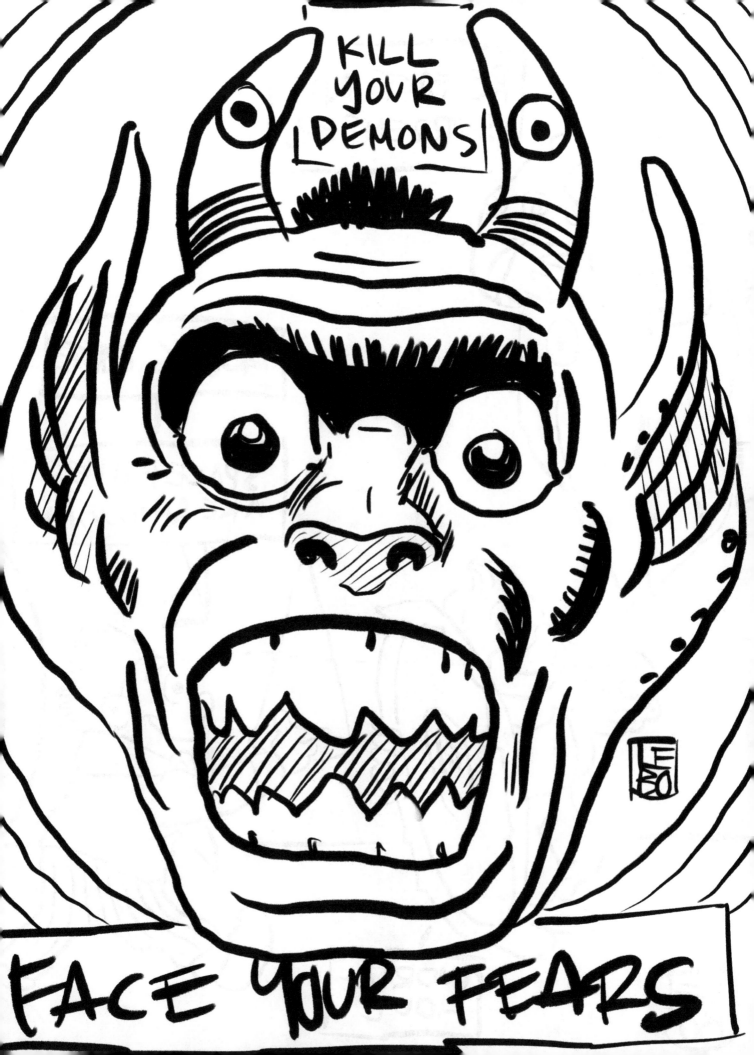

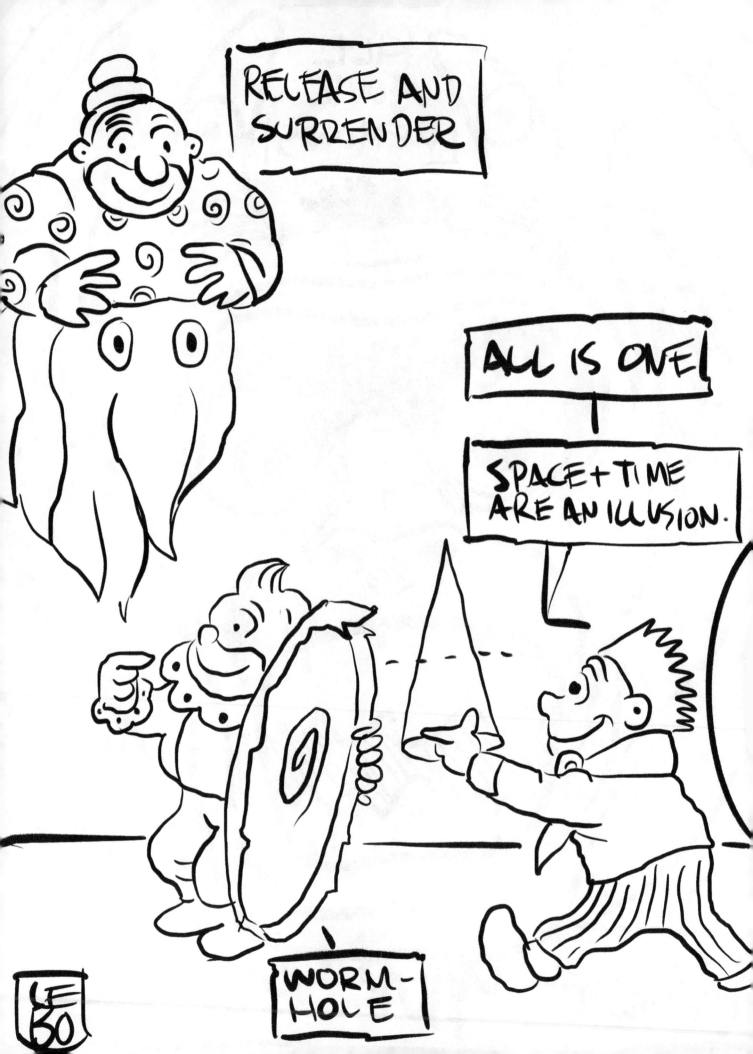

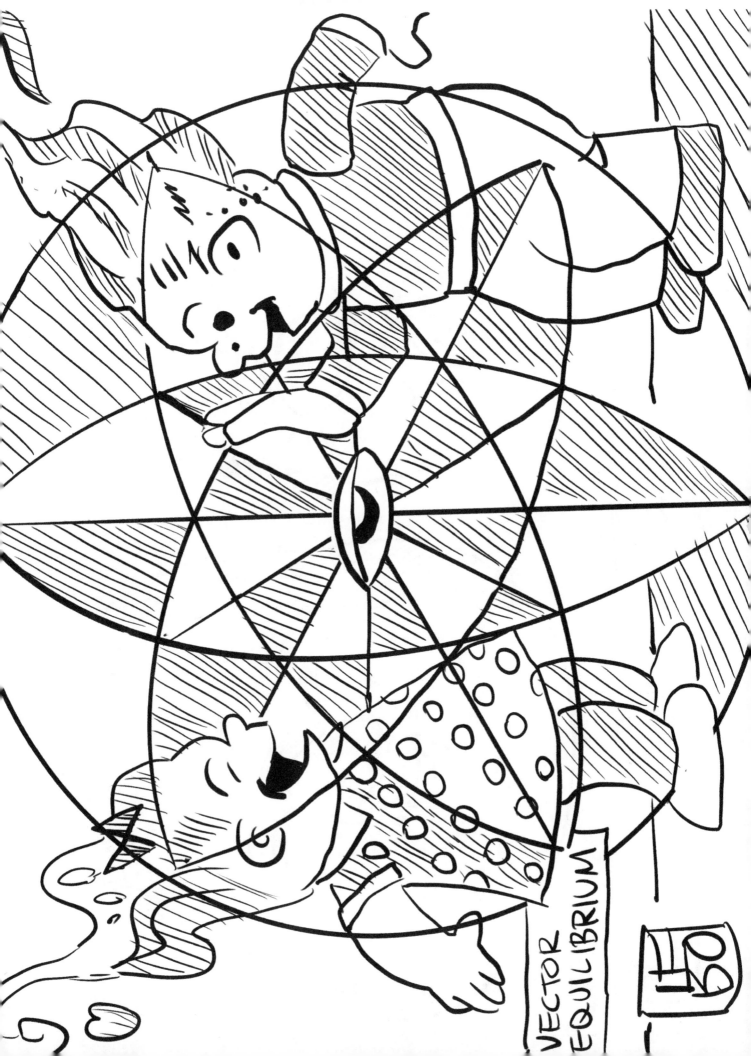

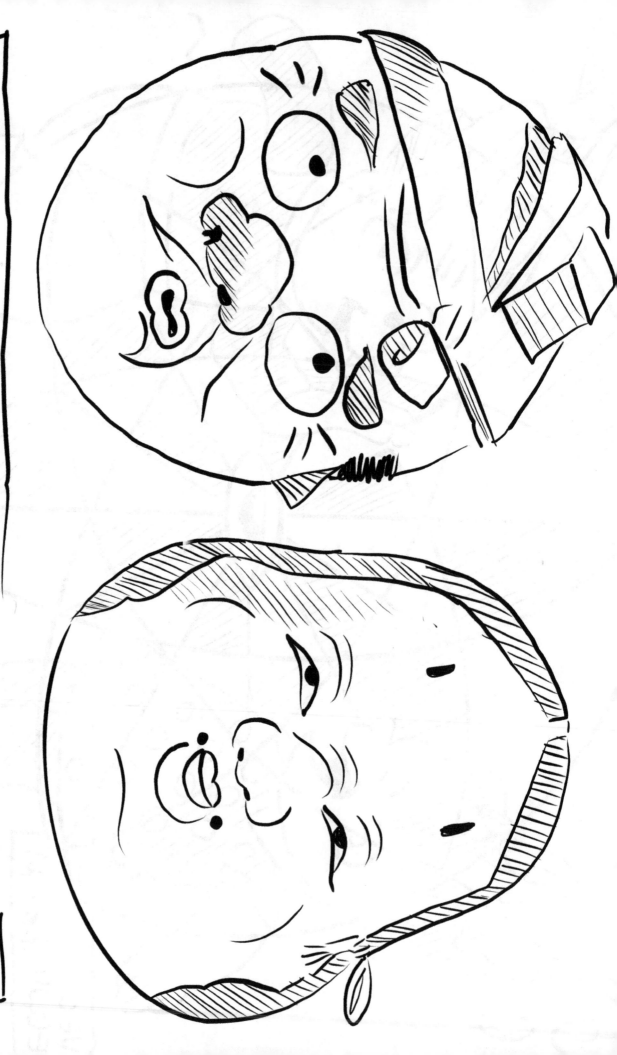

OTAFUKO AND HYOTTOKO:
JAPANESE FOLKLORIC MASKS

SAMURAI CRESTS

JAPAN
FEUDING PERIOD
1550 bce

GOTŌ

KAMEI

IJUIN

HIRATE

HŌJĀ

DOL

HISAMATSU

HOSOKAWA

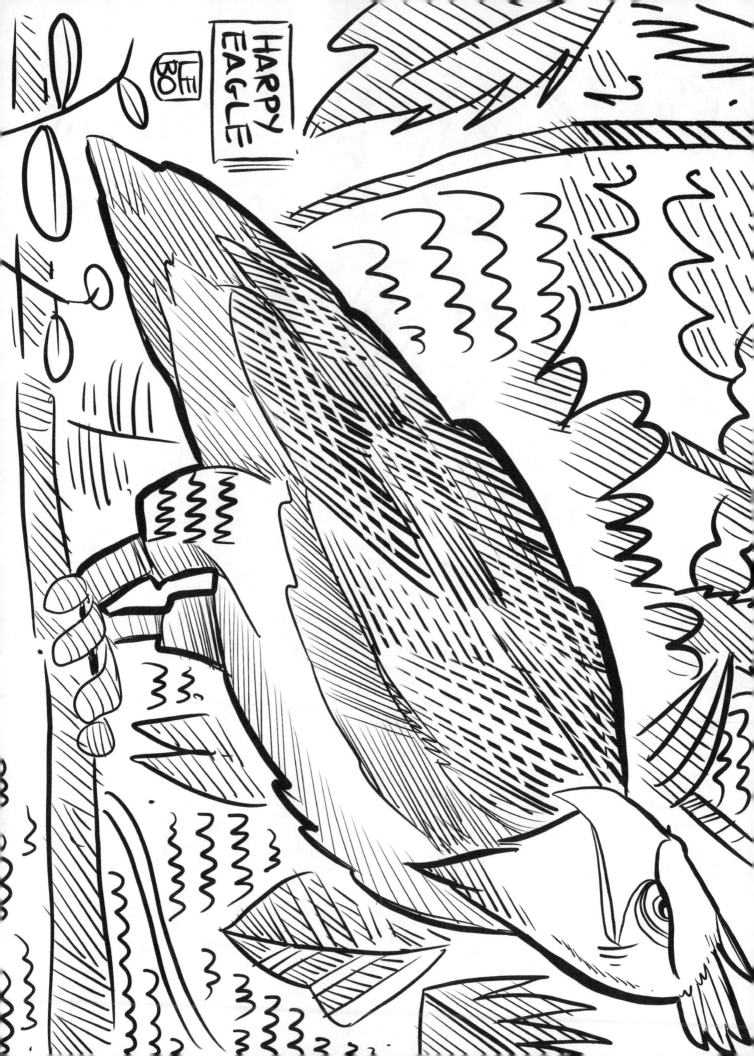

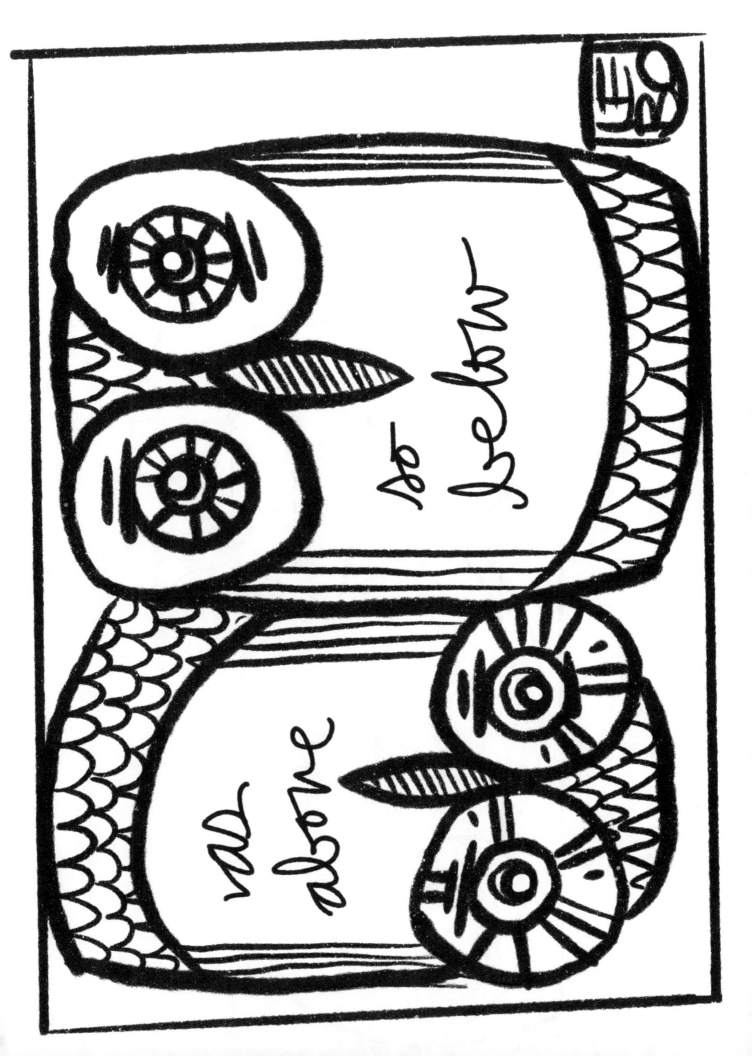

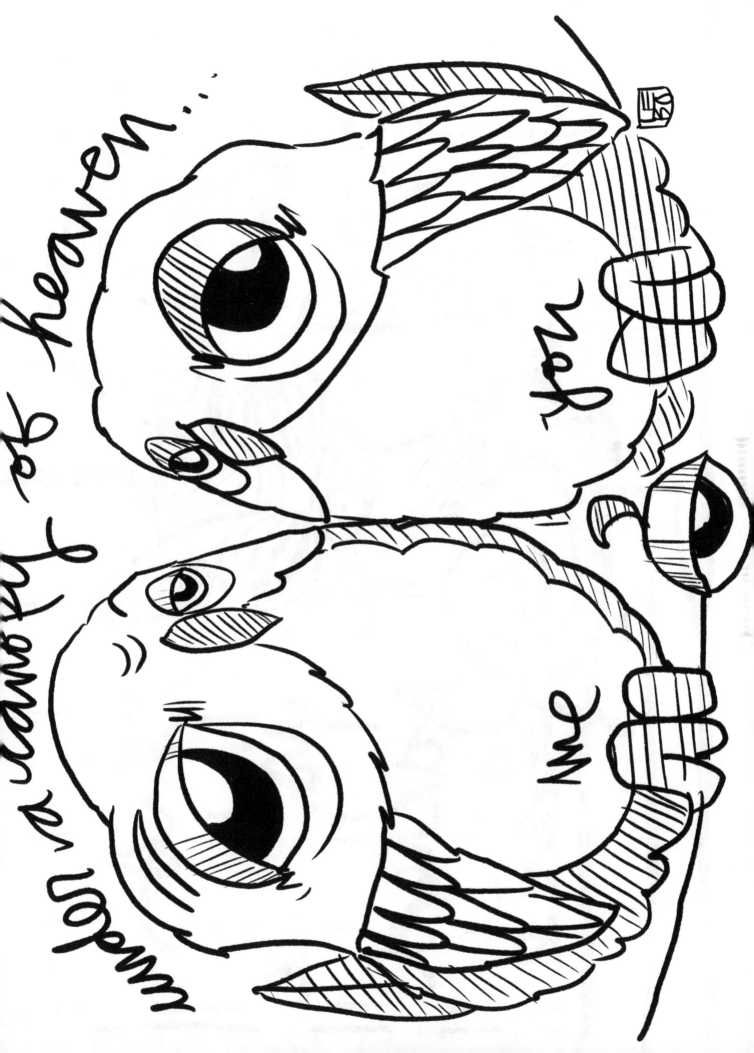

this is a
sacred place

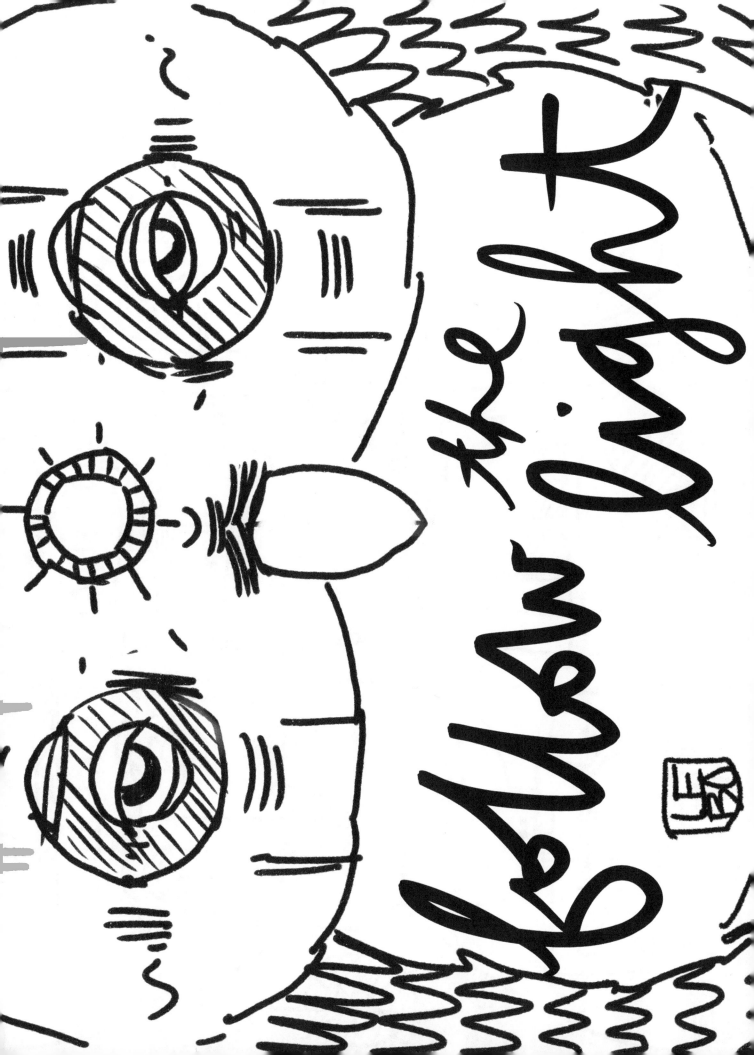

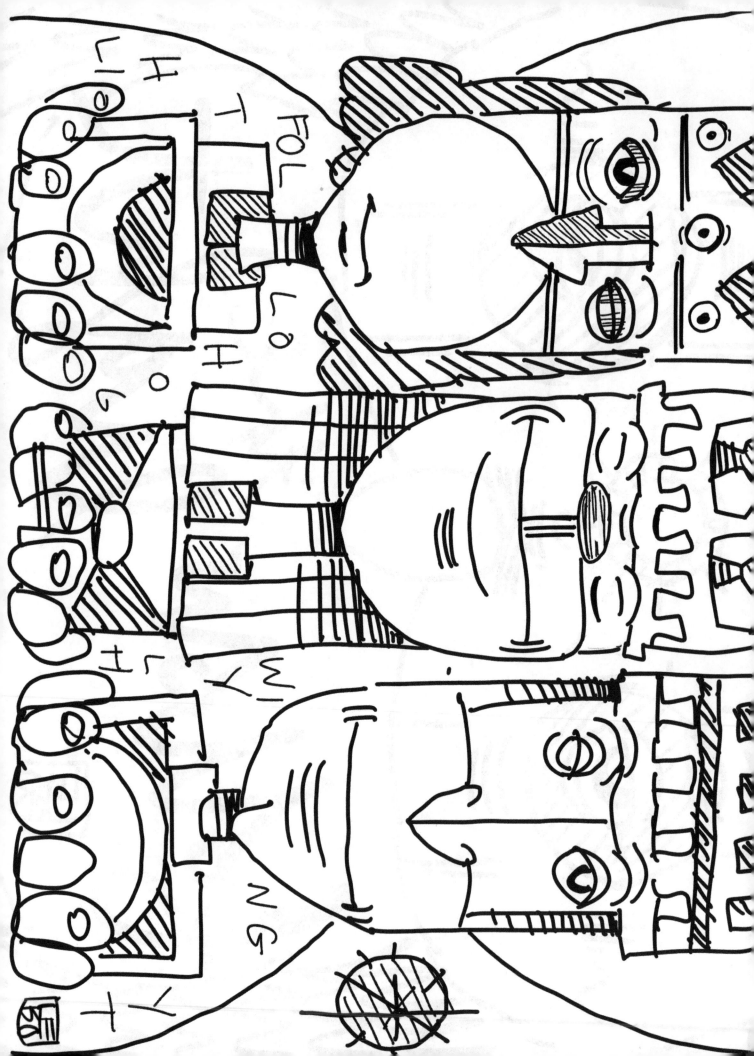

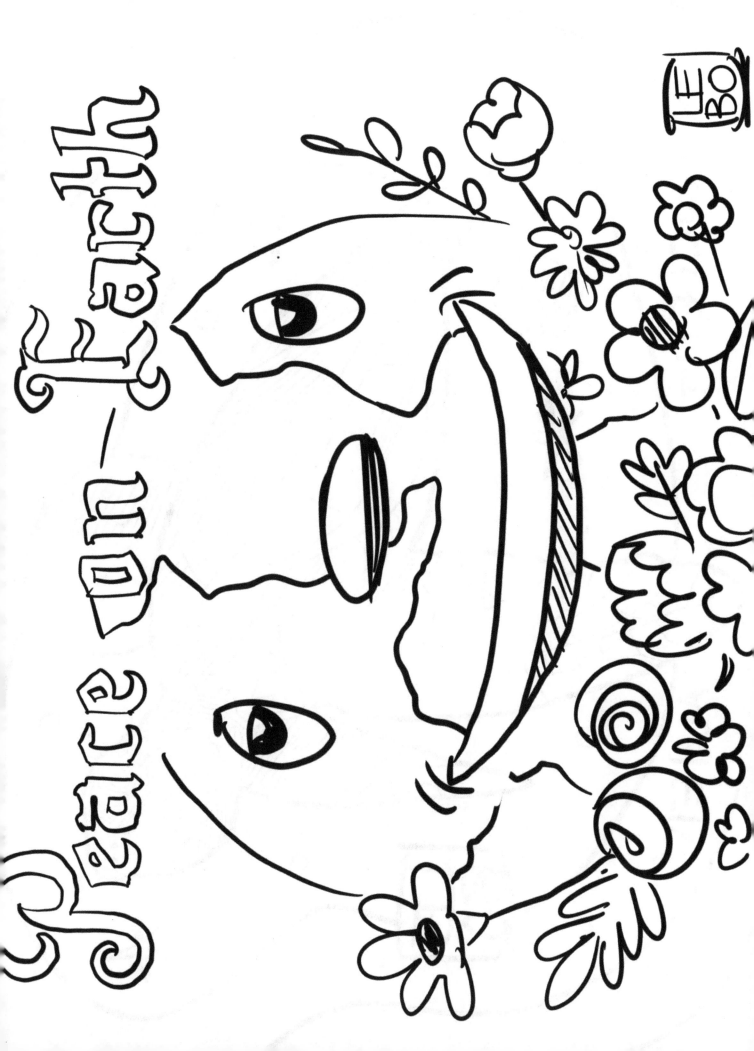

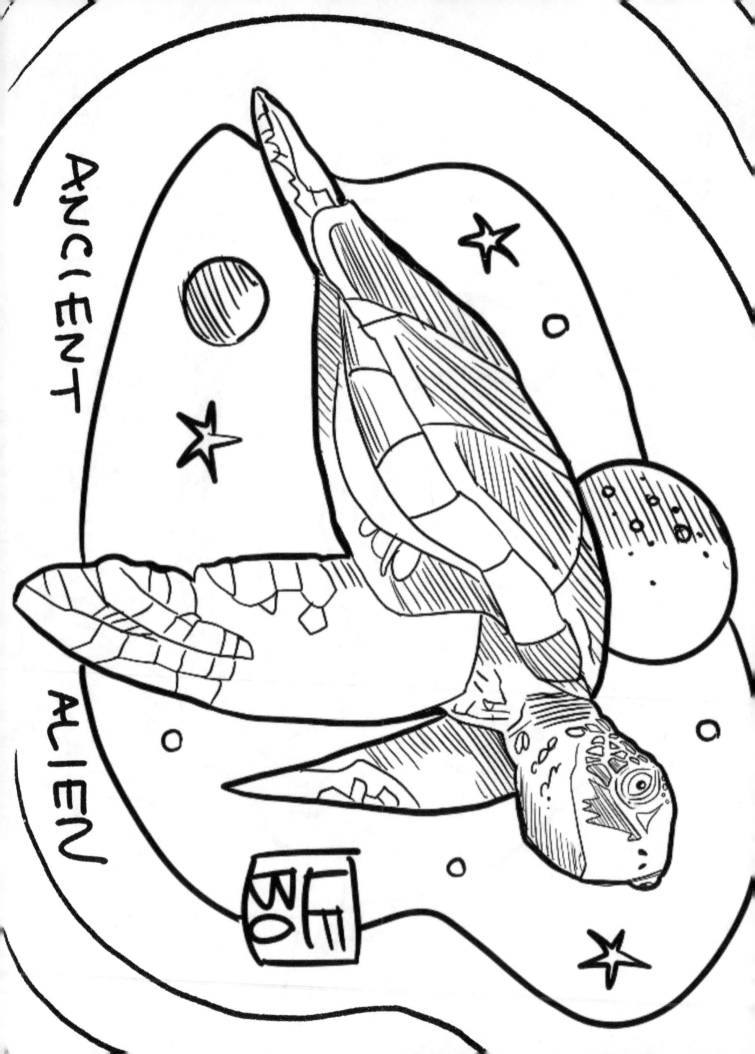

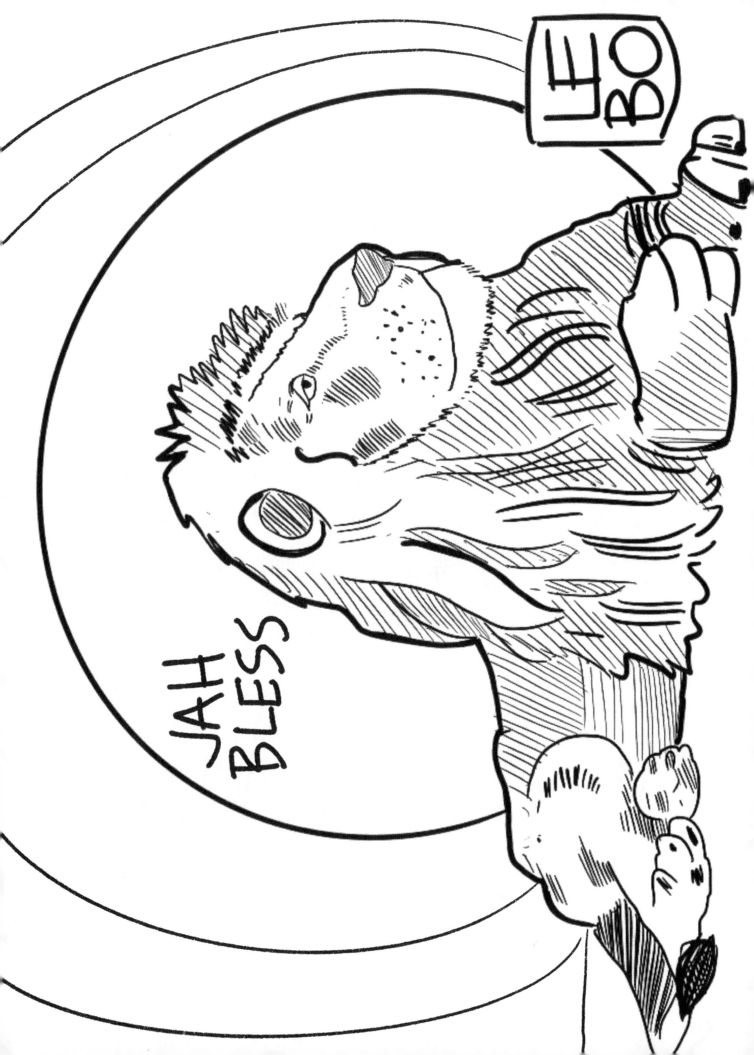

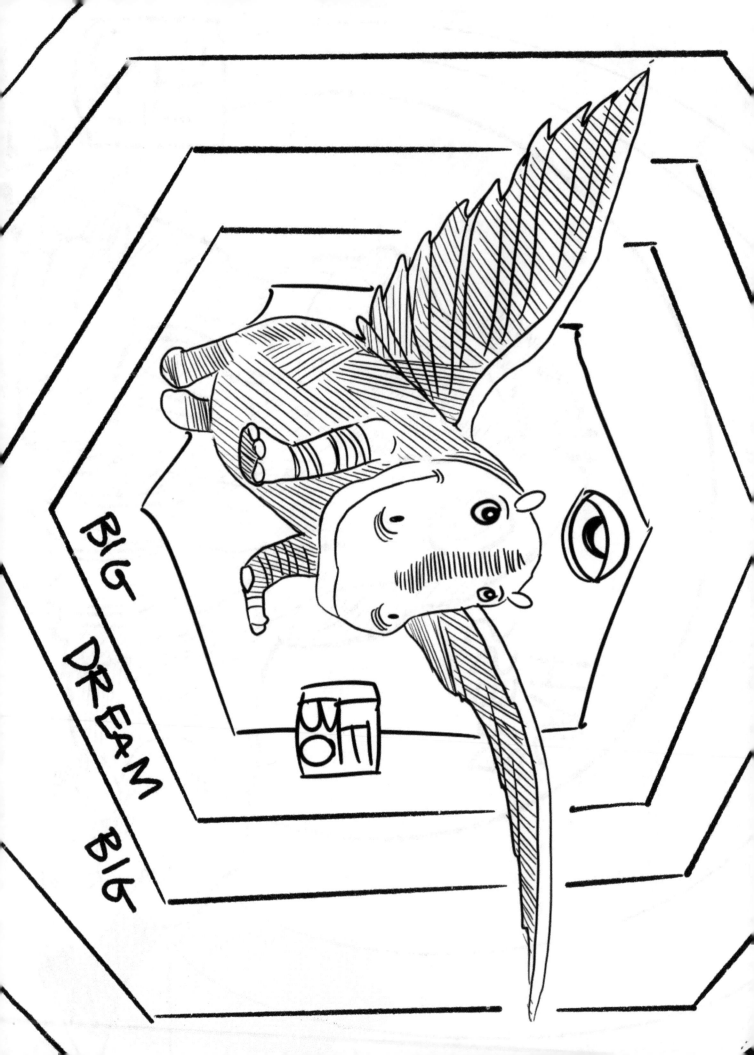

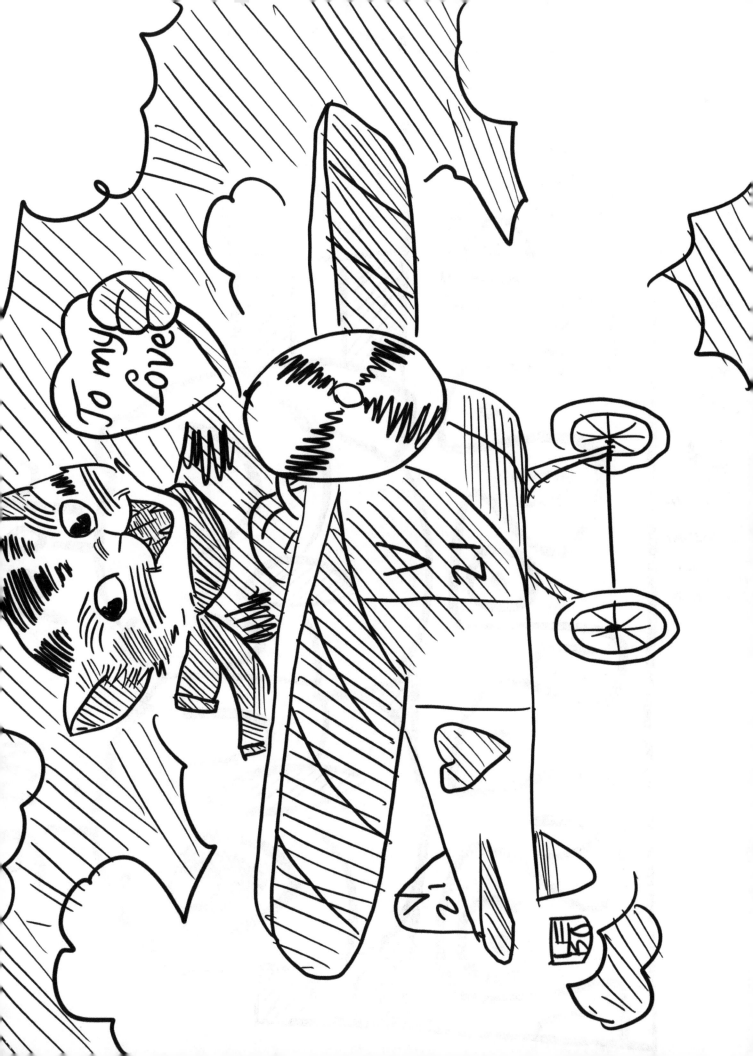

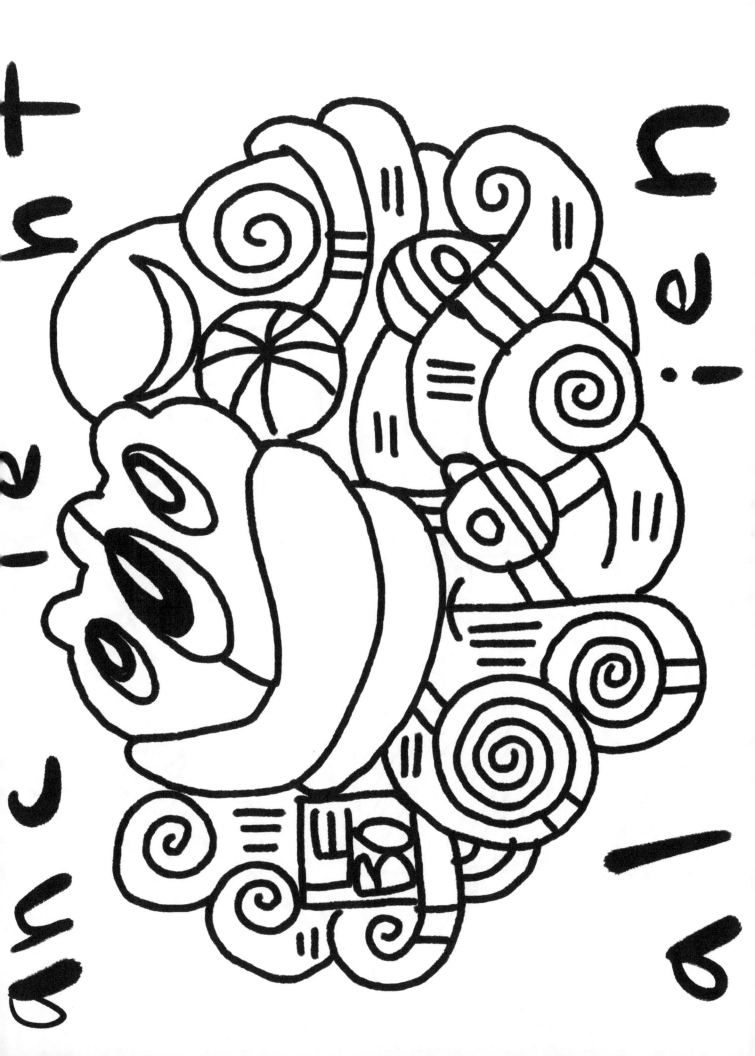

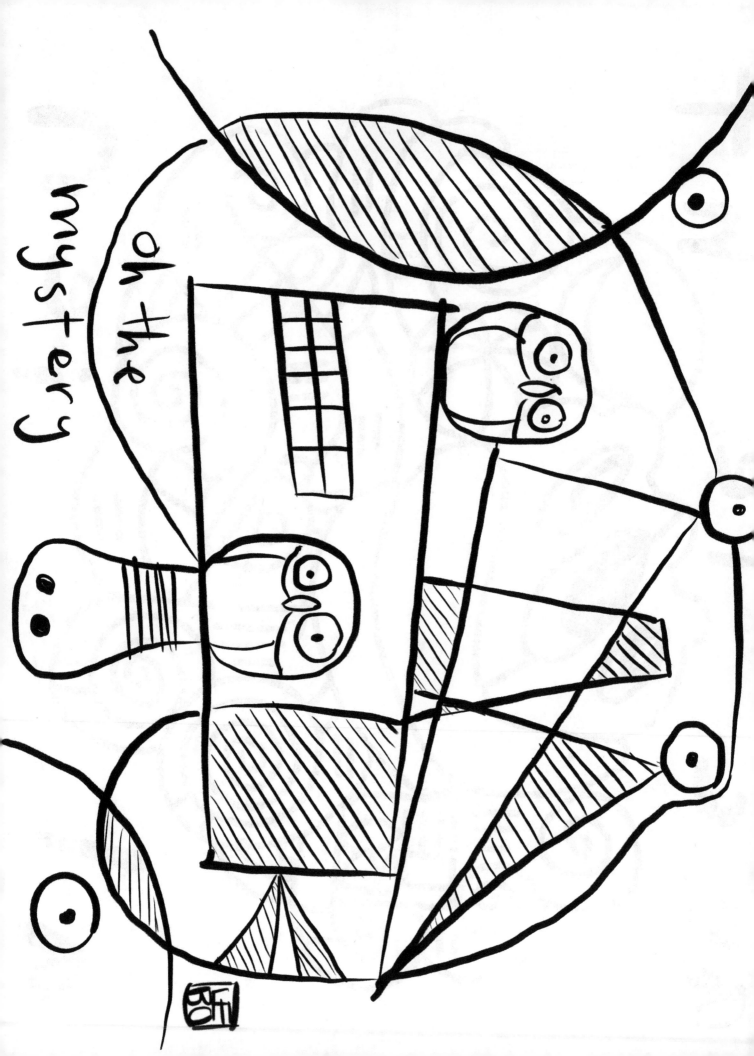

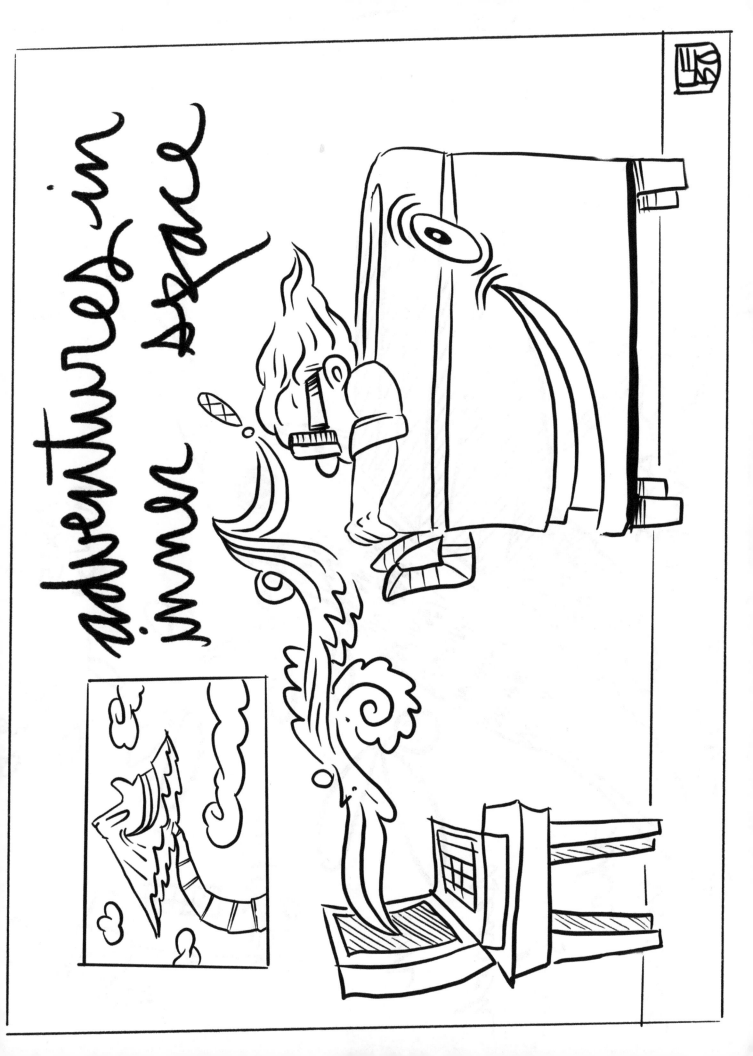

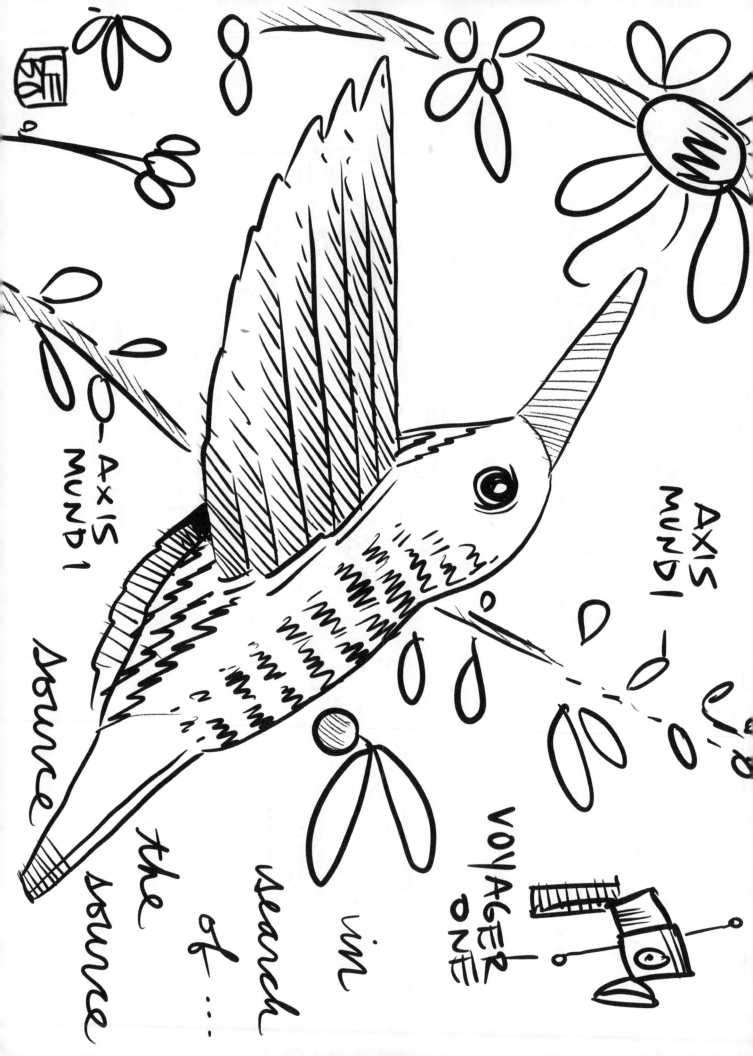

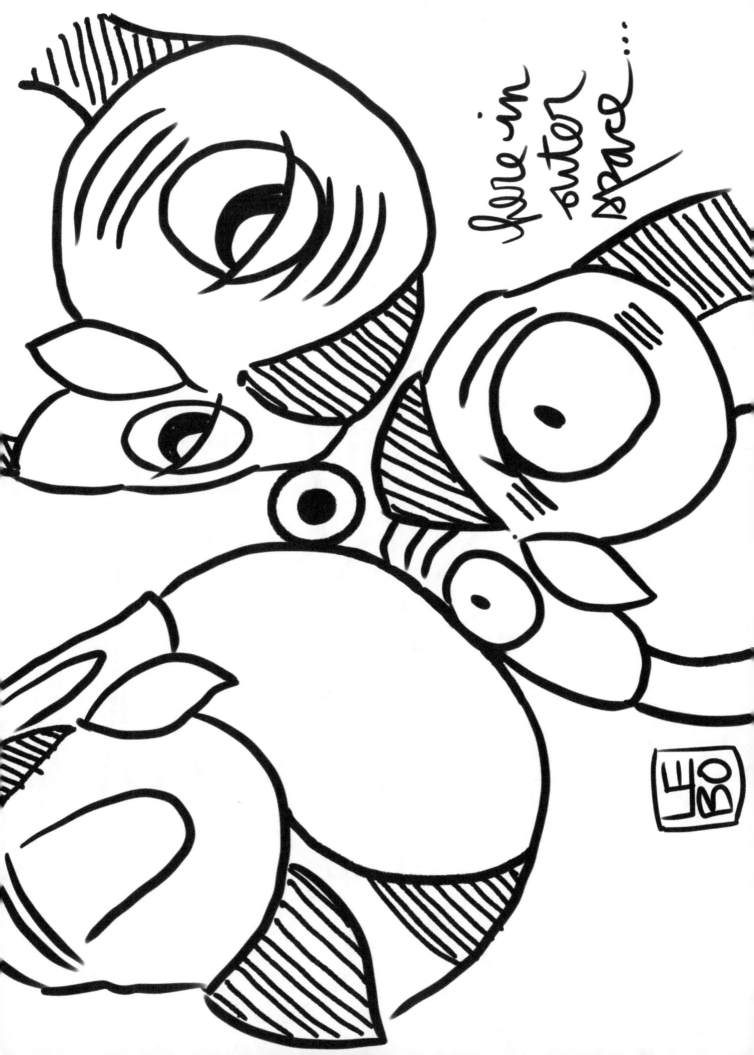

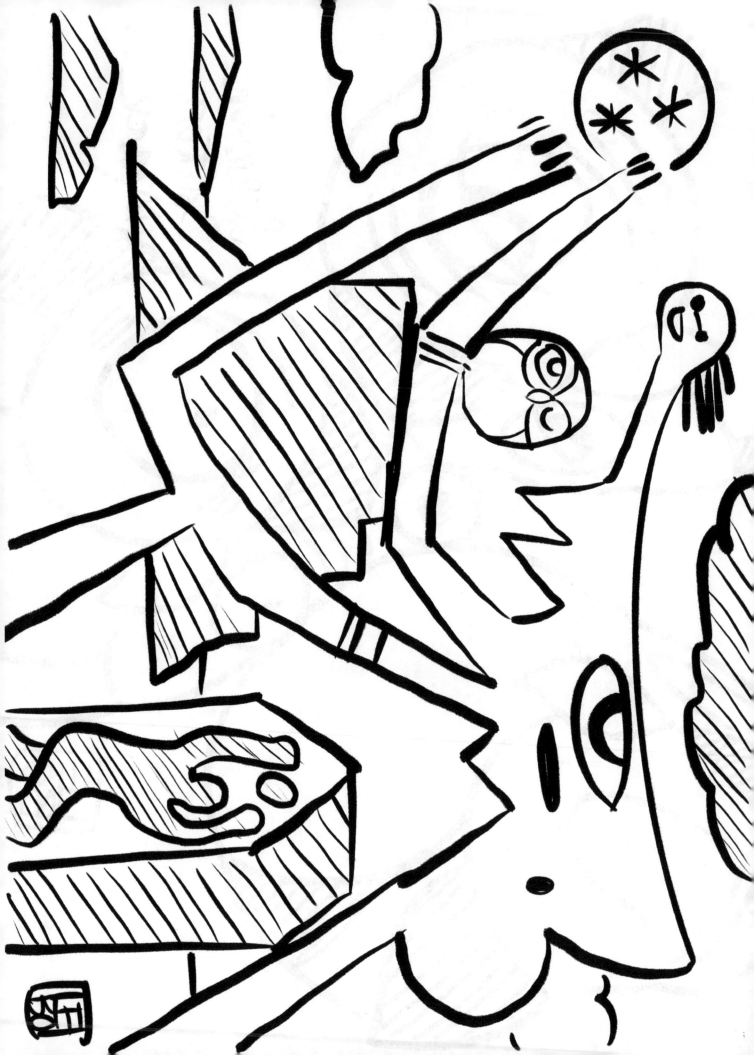

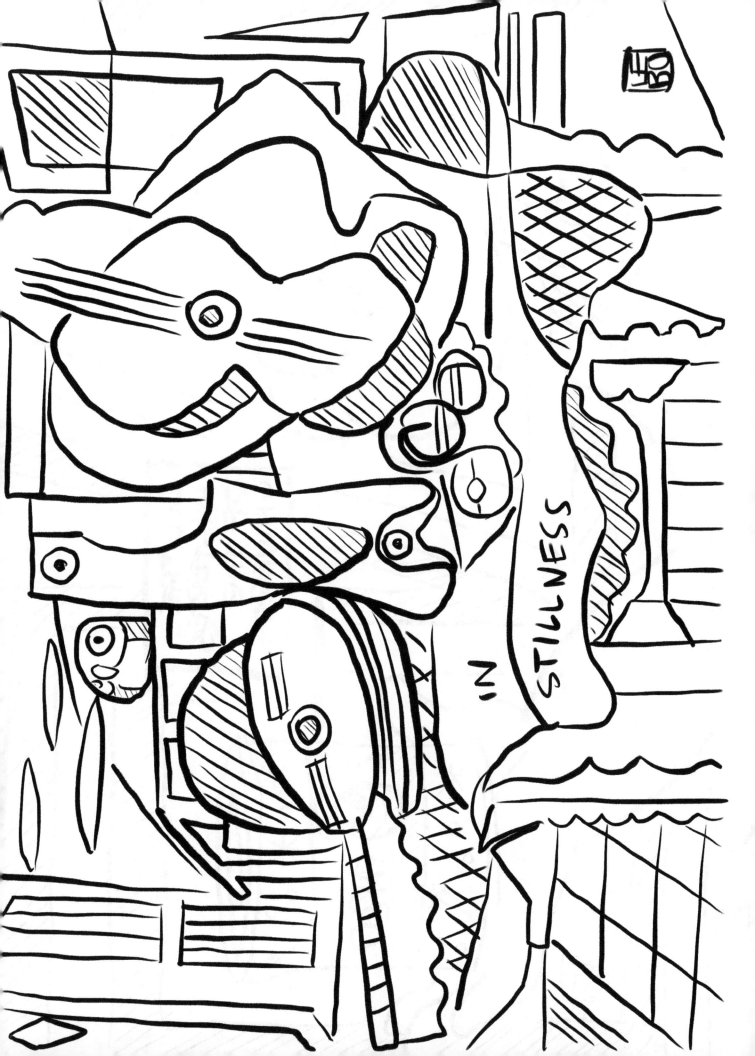

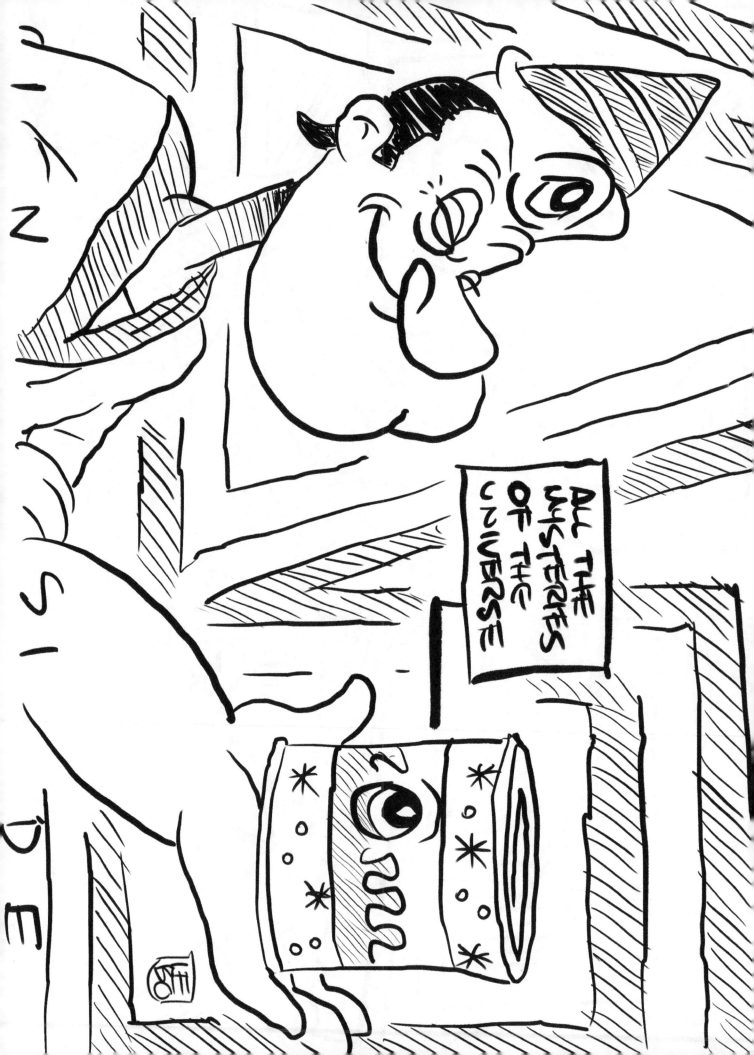

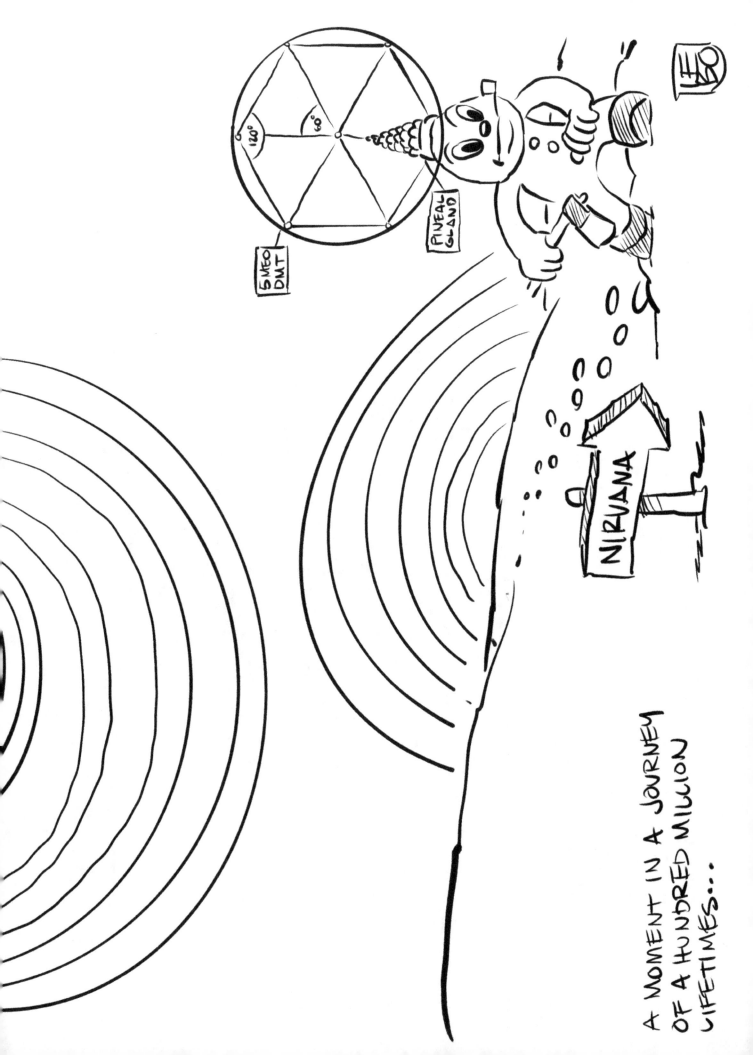

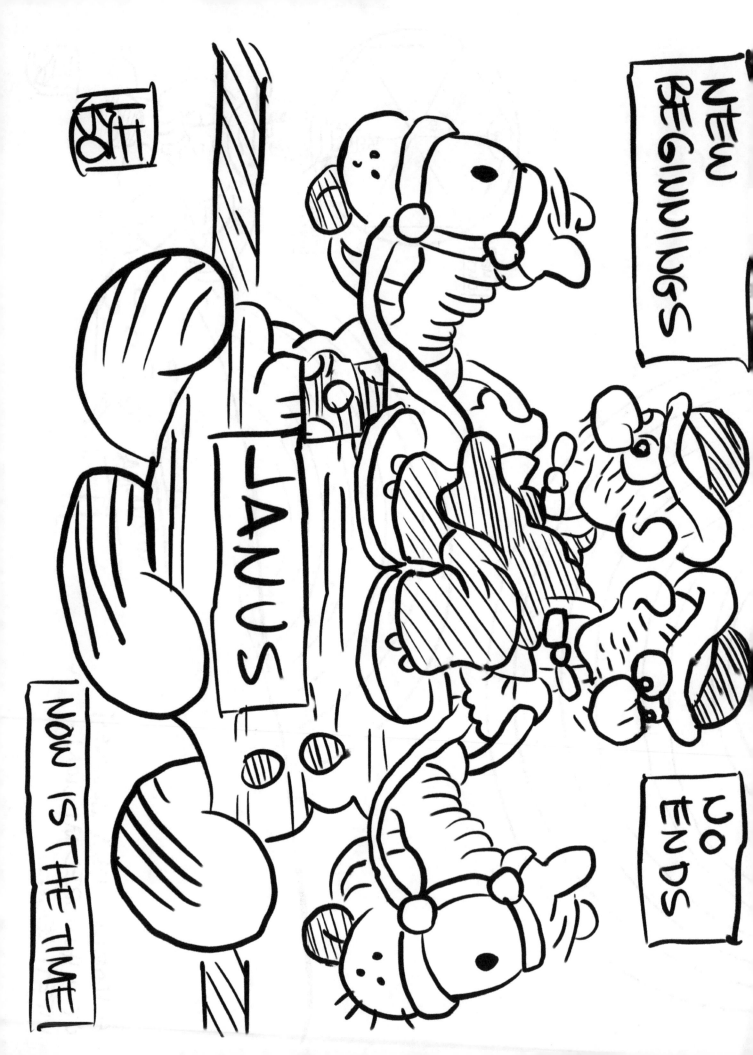

Mango Publishing, established in 2014, publishes an eclectic list of books by diverse authors—both new and established voices—on topics ranging from business, personal growth, women's empowerment, LGBTQ studies, health, and spirituality to history, popular culture, time management, decluttering, lifestyle, mental wellness, aging, and sustainable living. We were recently named 2019 *and* 2020's #1 fastest-growing independent publisher by *Publishers Weekly*. Our success is driven by our main goal, which is to publish high-quality books that will entertain readers as well as make a positive difference in their lives.

Our readers are our most important resource; we value your input, suggestions, and ideas. We'd love to hear from you—after all, we are publishing books for you!

Please stay in touch with us and follow us at:

Facebook: Mango Publishing
Twitter: @MangoPublishing
Instagram: @MangoPublishing
LinkedIn: Mango Publishing
Pinterest: Mango Publishing
Newsletter: mangopublishinggroup.com/newsletter

Join us on Mango's journey to reinvent publishing, one book at a time.